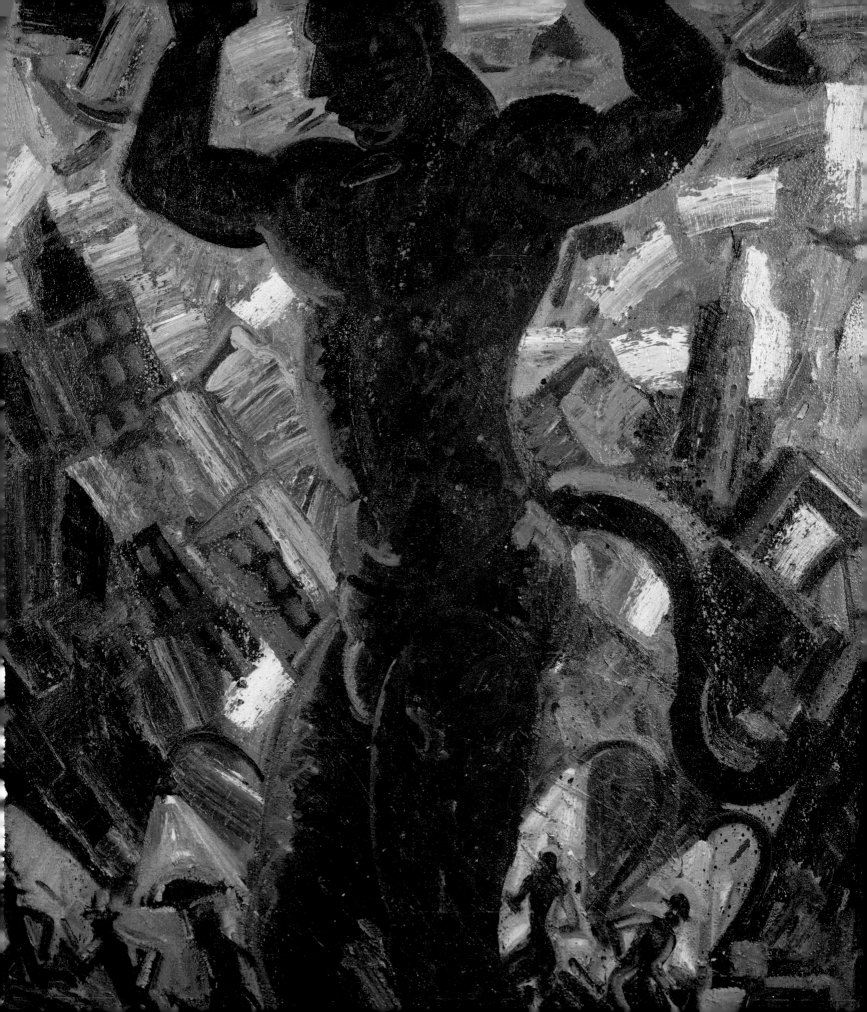

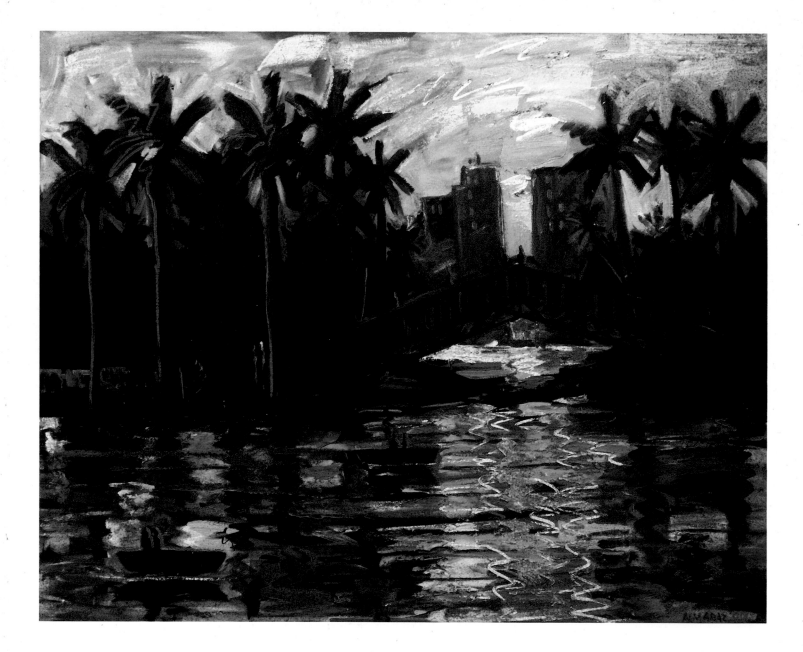

Echo Park Bridge at Night, oil on canvas, 1989

Playing with Fire

Paintings by
Carlos Almaraz

Howard N. Fox

Elsa Flores Almaraz, with Jeffrey J. Rangel

Maya Almaraz	Gina Lobaco
Barbara Carrasco	Cheech Marin
Patrick Ela	Suzanne Muchnic
Fritz A. Frauchiger	Louie F. Pérez
Marielos Gluck	Aimée Brown Price
Dan Guerrero	Monroe Price
Mark Guerrero	Joan Agajanian Quinn
Wayne Alaniz Healy	John Valadez
Judithe Hernández	Jeffrey Vallance
Craig Krull	

Carlos Almaraz

Published with the assistance of the Getty Foundation

LOS ANGELES COUNTY MUSEUM OF ART
DELMONICO BOOKS · PRESTEL
MUNICH · LONDON · NEW YORK

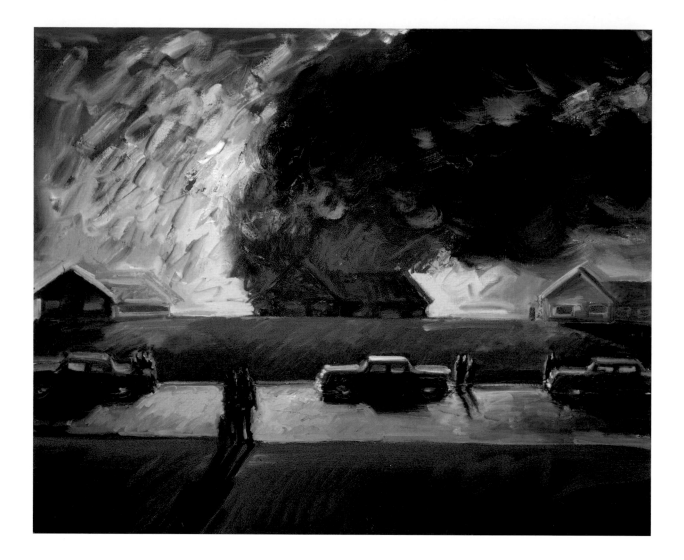

Suburban Nightmare, oil on canvas, 1983

Contents

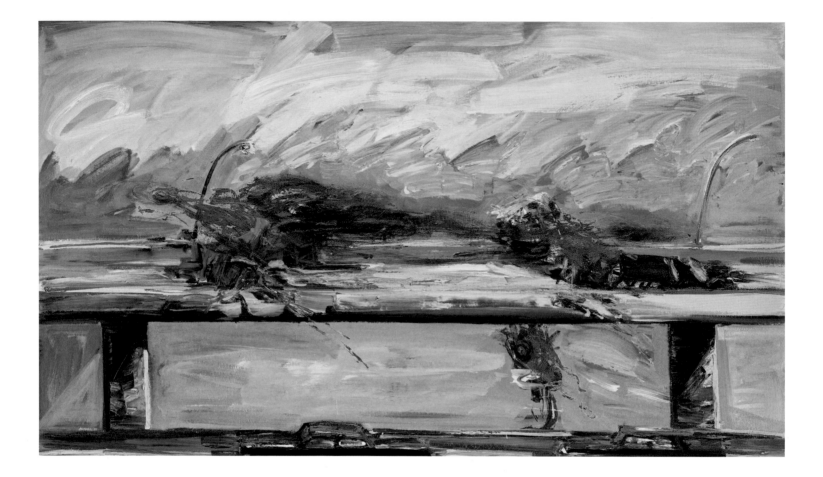

Crash in Phthalo Green, oil on canvas, 1984

Foreword

Eleven years ago, when I moved to Los Angeles to direct LACMA, I was asked whether I wanted any specific works of art for my office. I quickly perused LACMA's online database and chose Carlos Almaraz's *Crash in Phthalo Green*. It is stark and abstract, as powerful as a relatively small painting can be; in both its beauty and its form, the fiery, painterly car on an elevated highway seemed to capture the optimism as well as the complexities of the great metropolis. Not long after that, in working with Cheech Marin on the *Los Angelenos/Chicano Painters of L.A.* exhibition, I was finally able to delve into the rich history of Almaraz and his circle of extraordinary artist friends in a way I never had before.

So it's especially gratifying to see this exhibition and publication come to fruition. *Playing with Fire: Paintings by Carlos Almaraz* is the first survey at a major museum since the artist's untimely death in 1989 at age forty-eight. Almaraz is recognized among the first of many self-identified Chicano artists whose artistic, cultural, and political motivations begat a new art movement in the 1970s. He was legendary during his lifetime, initially as a charismatic political activist and as a cofounder of Los Four—the first of numerous Chicano artist collectives, or *groupos*, to spring up just as Southern California was emerging as an international focal point for new art—and ultimately as a visionary studio artist whose compelling and ravishingly colored images convey a deep psychological impact. Moreover, as demonstrated by the vivid and affectionate recollections from Almaraz's friends and colleagues in this catalogue, his impact on the Los Angeles art world was profound, and is still felt today.

During his lifetime Almaraz enjoyed numerous solo exhibitions, mostly in Los Angeles, highlighted by a historically noted mid-career survey, *Carlos Almaraz: Selected Works: 1970–1984: Paintings and Pastel Drawings* at the Los Angeles Municipal Art Gallery in 1984. After his death he was memorialized in 1991 by a show of works on paper, *Moonlight Theater: Prints and Related Works by Carlos Almaraz*, at the Grunwald Center for the Graphic Arts (UCLA). More recently, in 2012, the Vincent Price Art Museum at East Los Angeles College presented *Carlos Almaraz: A Life Recalled*, an exhibition comprising predominantly works on paper from the Almaraz Estate. Throughout his career and after his death, critical response to Almaraz's art often focused on his Chicano roots and his early involvement with *chicanismo*, the cultural movement he helped to inspire. Yet there was seldom direct interception with specifically Chicano issues in his mature art.

The aim of *Playing with Fire* is to reconsider the artistic achievements of Carlos Almaraz in a broader context than was generally accorded in his lifetime, including his work's affinities with both ancient Mesoamerican art and European modernism, its idiomatic iconography, and its engagement in complex issues around sexuality and gender. In doing so, we hope to develop a more inclusive and comprehensive appreciation of his art and to introduce his work to new and diverse audiences. We are especially proud to showcase this presentation as part of LACMA's programming for Pacific Standard Time: LA/LA, the multi-institutional initiative launched and in part sponsored by the Getty Foundation to explore Latin American and Latino art in dialogue with Los Angeles. Finally, we are exceedingly grateful to Howard N. Fox, who first brought Almaraz's work to LACMA in the 1980s and who has shepherded this exhibition and catalogue with great passion and commitment, and to Elsa Flores Almaraz and Maya Almaraz, whose gifts to LACMA have so enriched our holdings of this key figure in Los Angeles's cultural history.

Michael Govan
Wallis Annenberg Director and Chief Executive Officer
Los Angeles County Museum of Art

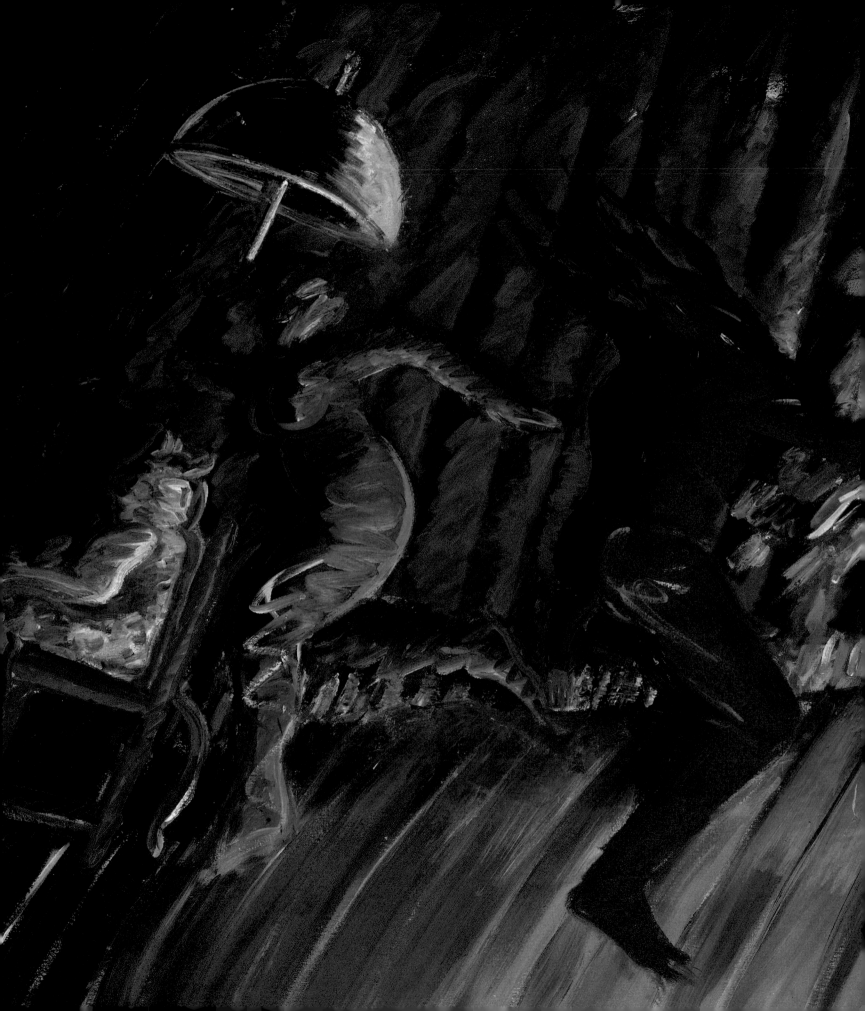

Playing with Fire

Howard N. Fox

Carlos Almaraz (1941–1989) has been widely, and justly, lionized as cultural revolutionary and a trailblazer in the Chicano arts movement of the 1970s.[1] Less has been made critically of his distancing himself by 1980 from the movement; indeed, most published references to Almaraz are quick to pronounce him specifically as a leading Chicano artist, even though there is very little imagery that is unambiguously "Chicano" in his mature work. As his wife, Elsa Flores Almaraz, has observed, "he always said, 'I'm an American artist who happens to be Chicano.'"[2]

While there were small surveys of his art during and soon after his lifetime, and accompanying exhibition catalogues with brief but thoughtful essays,[3] there has been no sustained exploration of his oeuvre. Now, nearly three decades following his untimely death in 1989 at age forty-eight, this is clearly a propitious time to reexamine Almaraz's too-brief but always compelling artistic achievements. His life was contradictory and often conflicted, and he reveled in and avidly celebrated the complexities and contradictions of his identity and experiences. These connections and slippages, these crossovers and disconnects, these harmonies and dissonances constitute the enduring essence of Almaraz's art.

Carlos David Almaraz was born in 1941 in Mexico City. About six months later the Almaraz family moved to Chicago, where he spent much of his childhood. Among his earliest memories was drawing his kindergarten classmates in their classroom: "I remember very distinctly that it was a very multinational, multicultural environment. I remember white children and black children and children of Hispanic origin, [who] could have been from Cuba, from Puerto Rico, from Mexico. Many of them were from Mexico, because the railroad used to end there."[4] This observation suggests that from a very early age he found the diversity that surrounded him to be alluring and stimulating—an appreciation that would deeply inflect the cosmopolitanism of his art and intellectual life as an adult.

Carlos and Rudy Almaraz, 1940s

The family moved to Southern California, eventually settling in East Los Angeles when Carlos was about ten. An unincorporated area in Los Angeles County with an almost exclusively Mexican population, East L.A. stood in vivid contrast to the young Almaraz's still-fresh impressions of his multiethnic experience at school in Chicago. Thus it would seem that in the experience of living in both a notably diverse social milieu and another that was even more notably homogeneous, even as a young man Almaraz discerned a tension—a conflict—of essential personal and cultural experience. On the one hand, he had enjoyed the experience of being surrounded by a palpable diversity; on the other, he had to reconcile himself to an equally palpable uniformity. This conflict is predictive of issues that would later play out in his artistic development.

But it was another childhood memory—a far more vivid one—that would profoundly inform his understanding of the power of visual art. The setting was the Metropolitan Cathedral in Mexico City, where the family would return to visit:

> I used to hate to go to church, and I'd start crying, and my mother would say, "What's wrong? Why don't you want to go to church?" And I'd say, "Because of the gorilla." And she'd say, "What gorilla?" I said, "There's a gorilla at church, and I don't want to see it." And she says, "There's no gorilla at church. There absolutely is no gorilla at church." So once again, she'd drag me, crying, to church. So we'd get there, I'd get on my knees, the mass would start, and I'd peek over the pew and look up to the far, far left, and there was the portrait of John the Baptist draped in furs, with a long furry beard, long hair, bushy eyebrows, and so covered in hair. Well, to a child of…four or five,…it could very [easily] look like a gorilla. And one of the reasons I mention this story is that, for me, my first impression of art was both horrifying and absolutely magical, because I really believed that was a gorilla, and it scared me….
> Yes, it's a painting of John the Baptist that confirmed my sense that art can be something almost alive.

Later, at James A. Garfield Senior High School in East Los Angeles, Almaraz first encountered art as a genuinely creative pursuit—not merely as a recreational activity, but rather as a personally reflective way of engaging with and interpreting one's world. After graduating in 1959 he studied briefly at Loyola University of Los Angeles and California State College, Los Angeles, and then for about two years at Otis Art Institute. These peregrinations made him realize that he needed to pursue art "in a real place where art is made, and at that time it was New York." In 1962 Almaraz moved to New York with his childhood friend, Daniel Guerrero; after about six months Almaraz returned to Los Angeles to resume his education at Otis and,

briefly, at University of California, Los Angeles. The East Coast, however, continued to beckon, and in 1965 he returned again to New York City, where he lived and worked for five years.

Almaraz arrived as an aspirant figurative painter in New York during the ascent of minimalism and conceptualism. It is clear, in retrospect, that he chose the wrong time and the wrong place to explore his own burgeoning artistic aspirations in relocating to an environment that was critically and commercially focused on the exaltation of austere visual vocabularies and industrial materials. With his innate predilection for figurative pictures, narrative scenarios, and dramatic color schemes, his aesthetic sensibilities were not merely out of keeping with the newly ascendant minimalist tenor in New York but were emphatically antithetical to it. His work found little traction, aside from participating in a group show at the Terrain Gallery, which had also sold a few pieces.

Few of his paintings from the period survive; those that do include a number of rather stifled-looking gridded works, worlds apart from the exuberant colors and dreamy figures that would populate his mature work. Almaraz appears here as a kind of dislocated minimalist wannabe, essentially mimicking a widely explored device—the grid—that was surging in visibility in East Coast art circles at the time. Yet his "minimalist" works were hardly minimal. For although they shared the compositional structure of gridded compositions, the information contained within his grids was neither formal nor neutral. They were informed with what appears as a fragmented, coded private language of pictograms and hieroglyphs, perhaps invested with veiled meaning just waiting to be decoded. It is as if, under the guise of the minimalist grid, Almaraz were telling a narrative without actually saying a decipherable word.

Almaraz returned to Los Angeles abidingly in 1970, haunted by feelings of disappointment and defeat. But coming home did not soon bring the restoration he'd no doubt hoped for. In fact, he would endure a near-total undoing, involving a bout with alcoholism and acute pancreatitis in early 1971 that resulted in his being hospitalized for more than six weeks, much of it in a drug-induced coma. As Elsa Flores Almaraz and Jeffrey J. Rangel discuss at length in "The Artist's Journey" later in this volume, his near-death experience in the hospital changed the trajectory of both his art and his life. During his recovery, through his friendship with fellow artist Gilbert "Magú" Luján, Almaraz engaged for the first time with the political and cultural issues of the Chicano movement. His consciousness-raising surprised even himself: "I never saw myself as a Chicano. I was a Mexicano living in the United States with Americanos. We did not use the word 'Chicano' in our homes to describe ourselves. We were Mexicanos." Nevertheless, he understood the marginalization

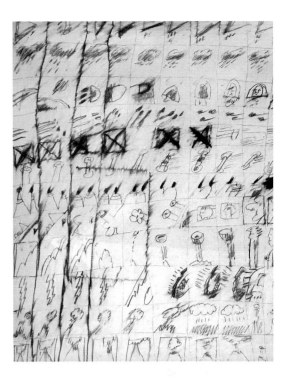

Grid Series, 1970

and struggle for political equality and cultural respect that Chicanos and most Latinos in America endured.

By 1972 Almaraz was active with the farmworkers' *causa*, led by union activist Cesar Chavez, painting banners for rallies and creating backdrops for playwright-director Luis Valdez's Teatro Campesino (Farmworkers' Theater). By switching the venue for his creative output from New York City to the farmlands of Central California, he found a new moral and political raison d'etre for his passionate creativity. Instead of working in a private visual language, Almaraz found himself crafting visual manifestos for a social revolution, helping to expose the near slave-like conditions endured by migrant agricultural laborers.

In tandem with his political activism, Almaraz also pursued his artistic interests within the growing Chicano artists community, and with Luján, Frank Romero, and Roberto "Beto" de la Rocha, he cofounded Los Four in 1973, one of the first Chicano artist collectives. More than a confederation of like-minded artists, they frequently collaborated with one another, sharing an interest in both muralism and graffiti

Los Four (left to right: Frank Romero, Carlos Almaraz, Gilbert Luján, Roberto de la Rocha), 1973

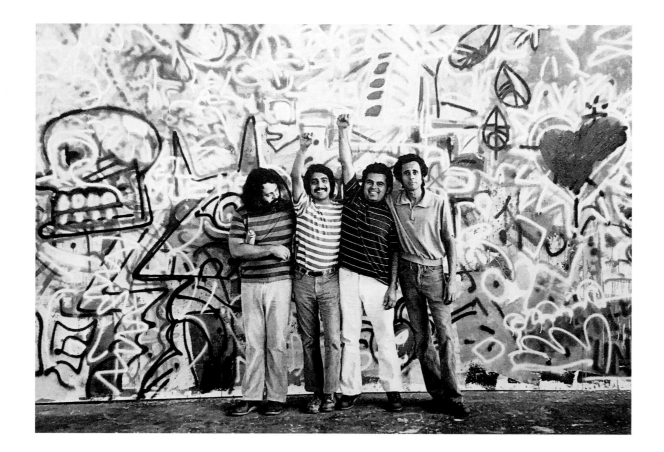

and adapting techniques of street art for their own artistic projects. Los Four stood as a united front against the popular conceptualization of the artist as an enlightened genius, a visionary fundamentally different from regular folks, and as a creator of masterworks to reflect eternal truths. Their first mural, made in 1973, was spray-painted in a single afternoon outdoors on the campus of University of California, Irvine. Each artist would work on a different part of the mural, then after a time would swap positions in order to freely rework one another's painting.

UC Irvine was also the venue for their first public exhibition, in November 1973. A greatly expanded version of the show, comprising of nearly two hundred works, was subsequently staged at the Los Angeles County Museum of Art, opening on February 26, 1974. *Los Four: Almaraz/de la Rocha/Luján/Romero* signified the first exhibition of the work of Chicano artists presented by a major museum. The opening reception was heavily attended—a fact owing as much to the quick-spreading notoriety of Los Four as to the novelty of LACMA's finally showing Chicano art.[5] Up to that point, the museum had a meager record in showing or collecting work by minority artists, and local artists generally criticized the institution for paying so little attention to Southern California artists even as many sensed that the region was on the precipice of emerging as an international art capital. For many attending the opening reception, perhaps, it was as if the gates had been crashed, albeit with the host's reluctant and overdue blessing.[6]

Los Four and their cohort sought to renounce what they saw as the effete vainglory of heroic modernism, and instead to engage the actual day-to-day world with a fidelity to its own reality. Not surprisingly, the radical social engagement of the Mexican muralist tradition was both a political and an artistic inspiration for Almaraz. During Mexico's post-revolutionary era in the 1920s–30s, artists such as David Alfaro Siqueiros, Diego Rivera, and José Clemente Orozco advocated for a national political, social, and cultural unity through their monumentally scaled works glorifying the country's ancient history, its heroes, and of course, its independence. Almaraz, during his first return to his homeland as an adult in 1969, sought out many of the major murals, studiously observing their spatial techniques, compositions, and messages—all elements that he brought to his work with the farmworkers and beyond. His first mural outside Los Four was *No Compre Vino Gallo* (Boycott Gallo Wine), painted in 1974 in solidarity with migrant laborers striking against Northern California's grape growers to protest the poor working conditions and wages in the orchards. Situated at the All Nations Neighborhood Center in East Los Angeles, *No Compre Vino Gallo* (p. 15) depicted the figure of a female farmworker raising her clenched fist in defiance of the police or security squad in riot gear at right.

The dramatic narrative culminated at its center, presenting the supine profiles of an indigenous-looking couple and an open hand (in contrast to the clenched fist) bursting through its enslaving manacles—a potent symbol of liberation.[7]

Almaraz continued to paint murals around Los Angeles, sometimes in collaboration with other artists, including Judithe Hernández, Mark Bryan, John Valadez, Elsa Flores, Barbara Carrasco, and other members of Los Four. In 1979 he designed an above-marquee mural for Luis Valdez's play *Zoot Suit* after it moved from the Mark Taper Forum in downtown Los Angeles to Hollywood's Aquarius Theatre. The play dramatized the street conflicts that erupted in Los Angeles in 1943 after groups of white sailors on leave attacked young Chicano men for wearing the flashy style known as the zoot suit.[8] Valdez's drama clearly exposed anti-Chicano racism and Chicano resistance in the face of it; Almaraz's temporary mural became a highly visible icon of the play and its thought-provoking subject.

For Almaraz, muralism was part of a broader rejection of private art, leaving behind the studio to participate in public venues, and proffering his cultural work—both as a gift and as an entreaty—to a broader audience in order to share fundamental social visions and beliefs. He articulated as much in "An Aesthetic Alternative," the hand-lettered manifesto that served as the announcement for his 1973 solo exhibition, *Paper Pieces by C.D.A.*, at Mechicano Art Center:

> I propose an art that is not private property; an art that may make other artists aware of their real duty as human beings. I propose an art that is not only an inspiration and an education but also an art form that is aggressive and hostile toward present bourgeois standards. I do not believe in "quality" because it's only a monstrous device by which those who can afford "quality" rule those who cannot…. For Chicanos, and all working class people,…*El grito* [the outcry] must be heard around the world. It must be loud and *con mucha fuerza* [with great force]. *El enemigo no es el Gabacho, mas bien es su BankAmericard, su swimming pools, su arte, y sus guerras que esclava el mundo* [the enemy is not the white man, but rather his BankAmericard, his swimming pools, his art, and his wars that enslave the world]….
>
> They have enslaved us with television, the English language and their credit system, and we continue to support it. *Basta!* El Movimiento is our only hope. The Movement is in the factories, in the fields, and in our homes. The artists must be part of it…. An artist should not need a studio. His studio should be in his pocket, on the sidewalk and in his mind. Let's make an art that is not only for ourselves, not for museums, not for posterity, and certainly not for art's sake, but for mankind.[9]

This stance in favor of public, politicized art contrasts startlingly with the highly personal studio practice that would ultimately prevail for him. Almaraz's proselytizing for Chicano political power and cultural pride demanded a deep inner commitment as well as a more public, community-based activism with the numerous galleries and organizations that emerged from the Chicano movement, such as Mechicano Art Center and Self Help Graphics & Art. But this contrasted, and perhaps even conflicted, with his interest in European art and art history, originally sparked by his academic studies and deepened through his travels in Europe and elsewhere. There was an inherent tug of war between his self-appointed mission as a public artist and his desire to nurture his inner artistic impulses that had been stifled by his years in New York and sidelined by his activism in Los Angeles.

This inner crisis came to a head around 1979. Producing the *Zoot Suit* mural that year nearly resulted in several serious accidents due to the artists' inexperience working with scaffolding. Also in 1979, Almaraz resigned from Los Four; as Elsa Flores Almaraz notes (p. 102), "the trajectories of their individual lives [had] diverged as Los Four became a concept for collaboration rather than the expression of its original four members." Further, as he recalled in his journals in 1980 (p. 121), playwright Luis Valdez told him directly: "You're very talented, and you're really doing too much. You really should do more of your own work, and in that way you will give people

No Compre Vino Gallo (Boycott Gallo Wine), All Nations Neighborhood Center in East Los Angeles, 1974

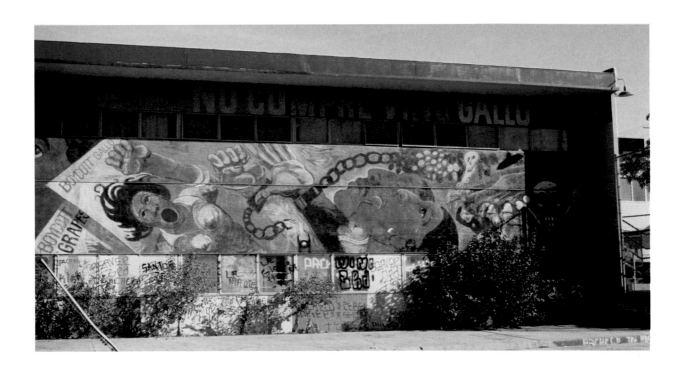

guidance." Altogether, these events prompted Almaraz to recognize his exhaustion with the cultural work he'd promoted in his revolutionary manifesto, which required for him a withdrawal from the very movement that he had been so instrumental in envisioning and articulating. As he wrote in the same journal entry, "I really had had it. I needed to return to the studio to do very personal work that was more or less the other side, my other aspect, my more introverted aspect, and to develop ideas that were nonpolitical, that were totally my ideas."

This was a remarkable turnaround for an artist who'd avowed just a few years earlier that "an artist should not need a studio"! From this juncture, Almaraz essentially began a second artistic career—the one for which he remains more lastingly known—as a studio artist making paintings, pastels, prints, and innumerable sketches in his notebooks. As his work evolved, it became ever more psychological, dreamlike, even mythic and mystical: indeed, Almaraz has been described as an urban shaman—a profoundly different role from fomenting social and political change through propagandistic imagery and declarative manifestos. Fellow Los Four cofounder Frank Romero recalled that some supporters started to think of Almaraz as a *vendido*, or sellout.[10] He was seen as betraying, or at least distancing himself from, the very movement whose ideological foundation and visual symbols he helped to invent: *chicanismo*'s affirmations, its resistance, its values, its iconography.

Removed from the public art milieu, Almaraz soon attained notable commercial and critical success as a solo artist through exhibitions at prestigious galleries on Los Angeles's Westside (as well as in San Francisco and New York). His artistic separation thus registered as geographic as well as cultural, even though Almaraz himself never relocated to the Westside. Rather, in his own aesthetic vision, it was time to move on. In the end his return to the studio was less a retreat from his artistic aspirations than it was a resolution or reconciliation of his inborn motives as an artist; he absolved himself from public activism and proselytizing for a shared and coherent *cultural* identity to an assertion and exploration of *personal* identity with all of its irreconcilable contradictions, clashes, and incongruities.

This change of direction had profound creative and personal ramifications. Following his rethinking of his own motives and aspirations, his work shifted markedly from his Chicano advocacy to a far more introspective mood that was nuanced and often ambiguous. If his previous public art was direct and declarative, his new personal art turned to an irrational dualism. These works still depicted the sights of daily life of Los Angeles, but now they became deeply interior, indeterminate, and more illustrative of his inner musings than of communally shared understandings or experiences. Almost inevitably, Almaraz wandered into the far less logical territory

of the human imagination, exploring dreamlike narratives.

In fact, much of what distinguishes Almaraz's mature art from that of many other first-generation Chicano artists is its fundamentally metaphorical nature. Where many other artists were reporting and celebrating the sights and events of daily life in Chicano culture, Almaraz became increasingly interested in multiple layers of content, encoded meanings, allegory and symbolism, and ecstatic imagery—a sort of visual art analogue to speaking in tongues. His art became more complex in its inspirations and sources, heavily influenced by both his Eurocentric art training and a deep and abiding interest in ancient Mesoamerican cultures as well as his own mandate to depict contemporary urban life and popular culture. By the early 1980s his art became so personal as to be aptly described as utterly singular.

On October 8, 1981, three days after his fortieth birthday, Carlos Almaraz married Elsa Flores in Cancún, Mexico. About a year and a half later their daughter, Maya, was born. Almaraz always had a deep desire for a family life, and honored and maintained it throughout his life as both a husband and a father. Prior to his marriage he had been in relationships with both men and women, a fact known to everyone (aside from his parents) close to him. Nevertheless, in the many accounts of Almaraz's activism and influence during that influential period, there is virtually no acknowledgment of his bisexuality: at most there were vague, euphemistic references to his exploration of both the "masculine" and "feminine" aspects of the human psyche—comments that were faintly redolent of Jungian psychological archetypical concepts but not really meaning much per se. Little wonder, given what Flores Almaraz characterizes as the repressive machismo of Chicano culture, as well as the broader cultural taboos that existed around being gay or bisexual at the time, particularly around HIV/AIDS.

While his bisexuality was known to those in his inner circle, Almaraz's public persona and his personal reality can be seen as constituting a kind of double life. Unstated though it was, Almaraz acted out this existential quandary in the dualities, the dualism of the subject matter that pervaded his studio art. For example, the idealized visions of Los Angeles's Echo Park and its lake juxtaposed with savagely ravishing pictures of violent car crashes; the endearing scenes of well-lived-in rooms and the disturbing images of houses on fire; tableaux of maternal love and devotion contrasting with depictions of street shootings. Even within a single work he might set figures in enchanted, dreamlike trances promenading amid a milieu of apparitions of goblins and phantoms. There is nothing outright sexual about any of these pictures— and yet they do collectively reveal an imagination deeply attracted to a dualistic comprehension of the world.

Suave Como La Noche (Soft Like the Night), 1985

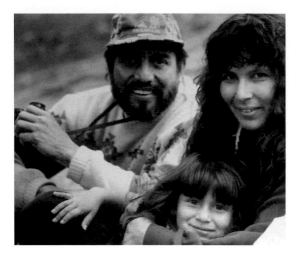

Carlos, Elsa, and Maya Almaraz, 1986
OPPOSITE: Carlos Almaraz, 1980s

In 1987 Almaraz learned that he had contracted HIV. From that time onward, his art reflected the gamut of emotions and hopes and fears of a highly expressive painter working at the top of his form as he faced his mortality. He remained loyal to his favored themes, but addressed them in newly modulated tones. From one work to the next, its mood could swing from lyrical to euphoric to foreboding, frequently depicting religious persecution, Catholic judgment, and sinners and guilt. His characteristic palette of highly saturated colors now sometimes shifted to a darker, duskier gradation, and his content was often overtly about death and destruction, but just as often could be contemplative or triumphant. *The Naked Jester* (p. 60) is a thinly disguised self-portrait, reflective and possibly remorseful of his prodigal nature, while *City Jaguar* (p. 71), another self-portrait, projects an awesomely monstrous and celebratory physical vigor.

Among Almaraz's very last paintings is *Deer Dancer* (p. 84). A figure sporting an antlered deer's head atop his own head sprints through an ambiguous swirl of floating images, including a nude woman, a house, a human skull, the familiar jaguar-man, and vestiges of the Los Angeles cityscape. The iconography of the stag, a male deer, crosses many cultures from the ancient Americas to Europe and Asia, and is often associated with masculinity, of course, but also with virility, fertility, majesty, and, in Christianity, with the Resurrection. The image—likely his final self-portrait—is especially haunting, completed during the final days, perhaps even the final hours, preceding his death.

Almaraz died in 1989, at age forty-eight. Nearly thirty years later, he is still routinely identified specifically as a Chicano artist—especially by his loyal and enthusiastic collectors, almost exclusively affluent Westside residents who acquired his work during his brilliant but relatively brief career. But while it is important to acknowledge his undeniable role in championing a visual art that pronounced itself as uniquely Chicano, Almaraz in fact straddled multiple and often contradictory identities that drew from divergent cultures and customs. He was born in Mexico and always felt he had cultural roots there, but he lived most of his life in the United States. Asserting himself as a Chicano meant that his cultural affiliation and his self-identity were marginalized by mainstream society in both countries. He was a true mythologist, ultimately believing not in the primacy or the uniqueness of any particular group but rather in the universality of the human imagination. Rather than cultural separateness or essentialism, he embraced crossover and hybridity. Carlos Almaraz emerges today as an exemplar of open-mindedness, of personal curiosity about human experience, of anybody's fundamental interest in sharing, in imaginative participation, and in the exploration our commonality manifested through art.

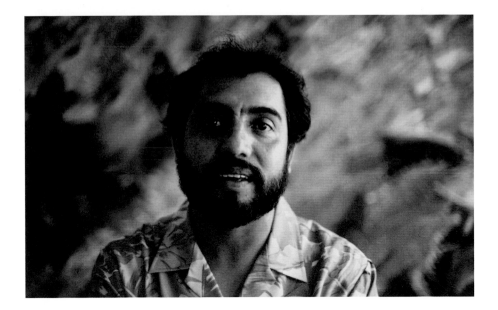

1. *Chicano* refers to Americans of Mexican descent; the term was sometimes used pejoratively until the 1960s–70s, when Mexican-American civil rights and labor activists began to adopt it proudly as a means of self-identification. *Chicanismo* refers to the movement's animating belief in cultural affirmation and political struggle.

2. Elsa Flores Almaraz quoted in Reed Johnson, "Carlos Almaraz's Time is Coming, Nearly 30 Years after Death," *Los Angeles Times*, March 8, 2014.

3. For example, see Peter Clothier, "A Lyrical Madness," in *Carlos Almaraz: Selected Works: 1970–1984, Paintings and Pastel Drawings* (Los Angeles: Los Angeles Municipal Art Gallery, 1984); Peter Frank, "Composing Exuberance," in *Carlos Almaraz: A Survey of Works on Paper, 1967 through 1989* (Los Angeles: Jan Turner Gallery, 1990); and Patrick H. Ela, "Advancing Toward the Light," in *Moonlight Theater: Prints and Related Works by Carlos Almaraz* (Los Angeles: Grunwald Center for the Graphic Arts, UCLA, 1991).

4. Carlos Almaraz, oral history interview conducted by Margarita Nieto at the Archives of American Art Southern California Research Center, Los Angeles, February 6, 13, 20 and July 31, 1986, and January 29, 1987 (aaa.si.edu/collections/interviews/oral-history-interview-carlos-almaraz-5409). Except where otherwise noted, all quotations from Almaraz in this essay are derived from Nieto's oral history.

5. In December 1972, the Los Angeles-based collective Asco (Patssi Valdez, Harry Gamboa, Jr., Glugio "Gronk" Nicandro, and Willie Herrón) spray-painted the names of three of its four members at the entrance of LACMA. Asco regarded this gesture as a guerilla intervention into the cultural establishment and—with justification—claimed to be the first, if unsanctioned, display of Chicano art at the venue.

6. The exhibition was documented on video, and is available as part of James Tartan's *Los Four/Murals of Aztlán: The Street Painters of East Los Angeles* (UCLA Chicano Studies Resource Center, Chicano Cinema and Media Art Series, vol. 1, 2004).

7. *No Compre Vino Gallo* was painted over in the late 1980s. As of March 2017, the online archive of the Los Angeles Mural Conservancy (muralconservancy.org/murals) lists the following murals as still extant: *Por El Pueblo*, California State University–Los Angeles (1975, Los Four); *La Adelita*, Ramona Gardens (1976, designed and painted by Almaraz, signed Los Four); *La Mujer,* Ramona Gardens (1976, Judithe Hernández and Almaraz); and *The History of L.A.*, East Los Angeles (1980, Almaraz assisted by Guillermo Bejarano).

8. In the late 1930s and early 1940s, zoot suits—composed of long, wide-shouldered jackets and exaggeratedly full pegged trousers—were popular among urban African American and Latino youth subcultures. In 1942 the War Production Board imposed restrictions on fabrics, and zoot suits and their wearers (known as *pachucos* in Latino communities) came to be seen by some as not just criminal but unpatriotic. See Kathy Peiss, *Zoot Suit: The Enigmatic Career of an Extreme Style* (Philadelphia: University of Pennsylvania Press, 2011).

9. Carlos Almaraz, "An Aesthetic Alternative" (Los Angeles: printed by the author, 1973), Documents of 20th-Century Latin American and Latino Art, International Center for the Arts of the Americas at the Museum of Fine Arts, Houston (icaadocs.mfah.org/icaadocs/THEARCHIVE/FullRecord/tabid/88/doc/1083115). He also presented the manifesto as part of his master's thesis at Otis.

10. Frank Romero, in conversation with the author, May 19, 2016.

Los Angeles, Delirious and Edenic

After turning from his career as a political activist and muralist, Carlos Almaraz worked nearly constantly during the decade or so that he was a studio artist. He returned frequently to a set of favored themes throughout his oeuvre. Mirroring his studio practice, *Playing with Fire* is organized thematically rather than chronologically. The themes identified here are by no means mutually exclusive, and in the exhibition installation they are not segregated from one another in bounded spaces but flow loosely from one zone to the next. Of course, there are some works that do not fit neatly into any of these loosely described themes; they are dispersed variously in the exhibition and here.

🌴 🌴 🌴

In the world of Carlos Almaraz, the urban setting of Los Angeles is a locus of all human desires, aspirations, and ambitions. He often painted the city as a place of surging visual energy and human activity, a raucous orgy of infinite possibilities, all of it bordering on the verge of chaos. His L.A. is an alluring, beckoning world, and a dangerous place. Renderings such as *Love Makes the City Crumble* (1983) are visually jarring, disorderly pictures—fantastical visions of a densely built-up high-rise city, physically swashbuckling in its own maniacal energy. The skyscrapers are hardly the stolid, flat-topped stone, steel, and glass edifices that actually do populate the streets of Los Angeles; these spires bend, twist, and dance with a rapture evoking unbridled bodily abandon, as if in a dance or other unruly physical glee. In some of his paintings, strange, Dantesque figures, almost ghoulish, inhabit the space beneath the pavement; yet his many cityscapes are always joyous, riotous depictions of hyper-energized activity.

In dramatic contrast to Almaraz's rowdy cityscapes are his many pictures of Echo Park, which stand as paeans to an urban oasis of lyrical serenity. He loved depicting the park with its rolling lawns and its lake ringed with palm trees, paddleboats on the water, and a Venetianesque footbridge. In Almaraz's cityscapes—like his images of his and Elsa's second home in Kauai, Hawaii, another idyllic locale that appears prominently in his oeuvre—Echo Park is a kind of Eden, an urban paradise and a place to search for love. The majestic four-panel vista *Echo Park Lake* (1982)—reminiscent of Claude Monet's lily ponds and Parisian parks—is a tour de force of color and texture, while *Bridge in Deep Magenta* (1984) is a painterly hymn not only to the lake, but to all of Los Angeles at twilight. Of course, Echo Park is not truly pastoral or rustic at all, but Almaraz treated it with an appealing simplicity and charm in a manner that extends the European tradition of the idyll to include his many renditions of this urban greenspace, from golden glowing morning to broadly hued midday to enchanting moonlit nocturnes.

Echo Park Lake, no. 4 (detail), 1982

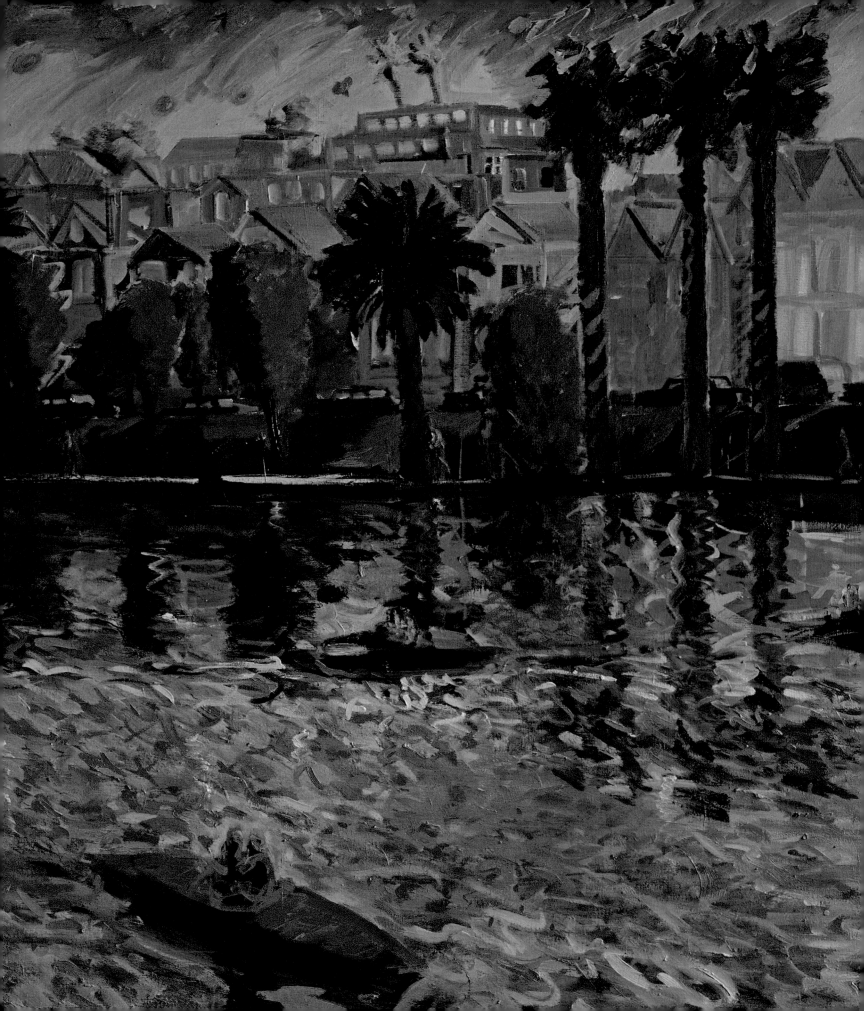

California Natives, oil on canvas, 1988

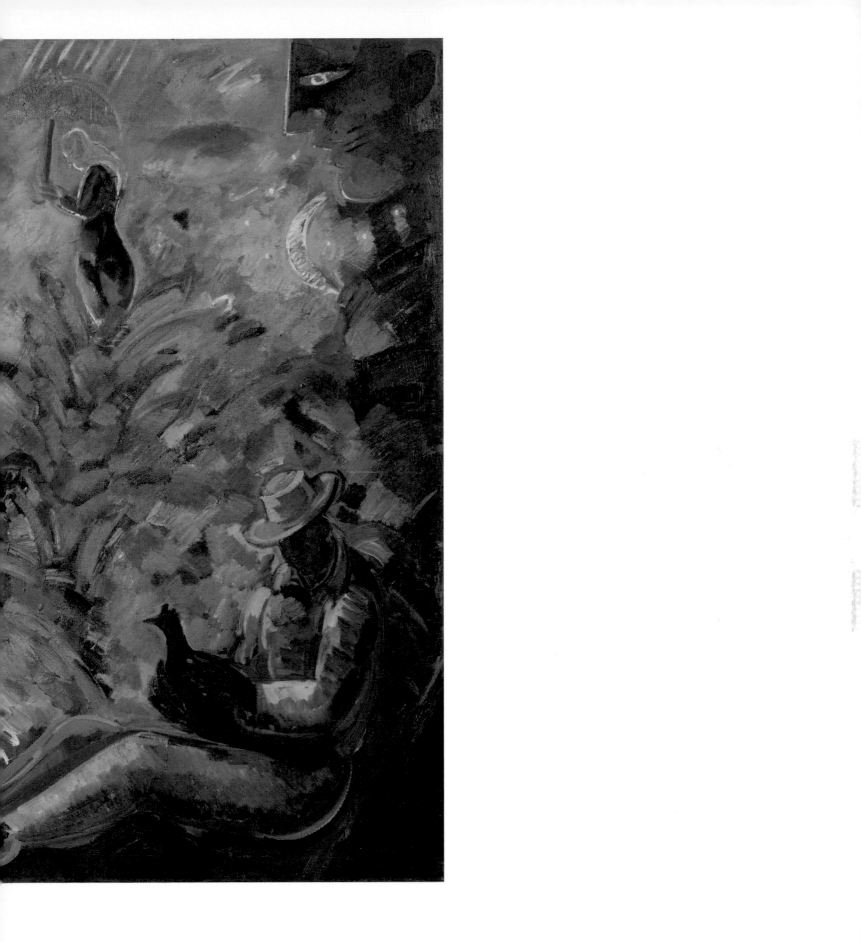

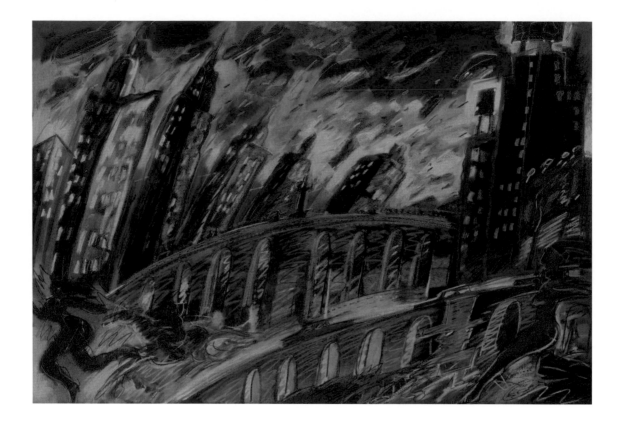

Growing City, pastel on paper, 1988

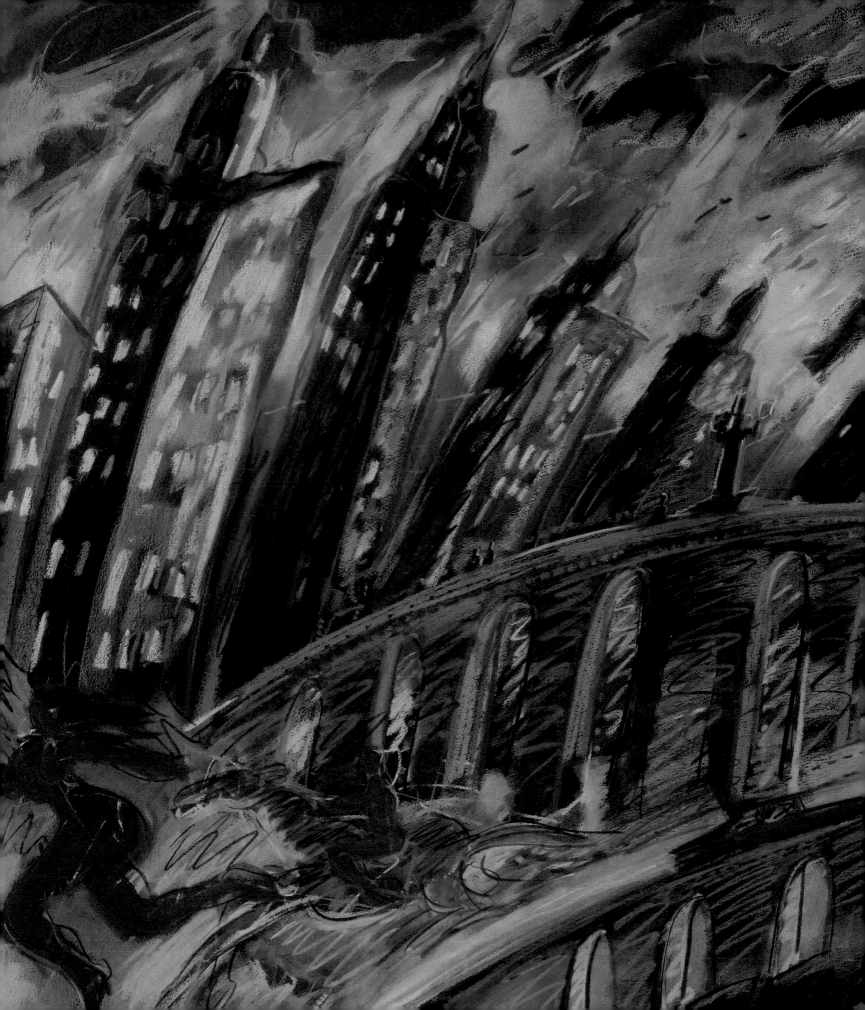

Echo Park Lake, nos. 1–4, oil on canvas, 1982

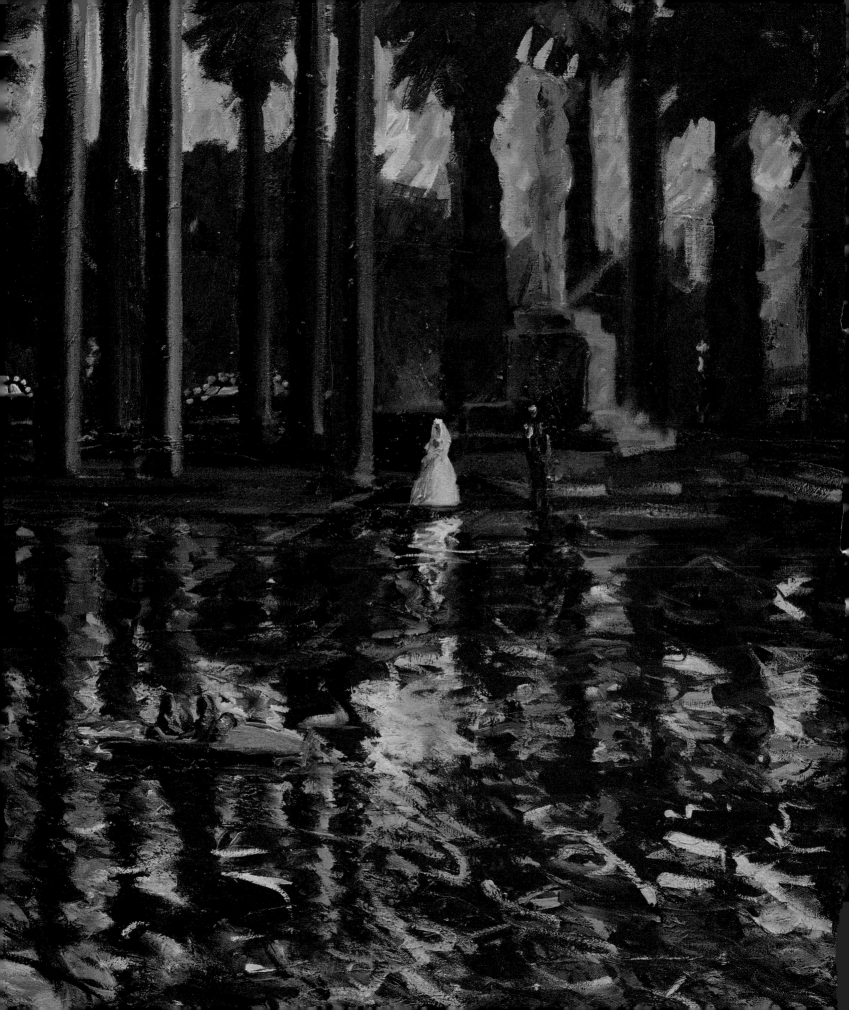

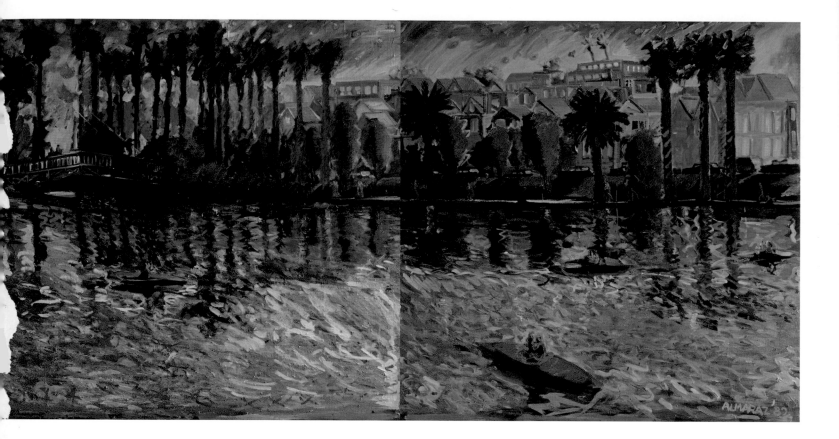

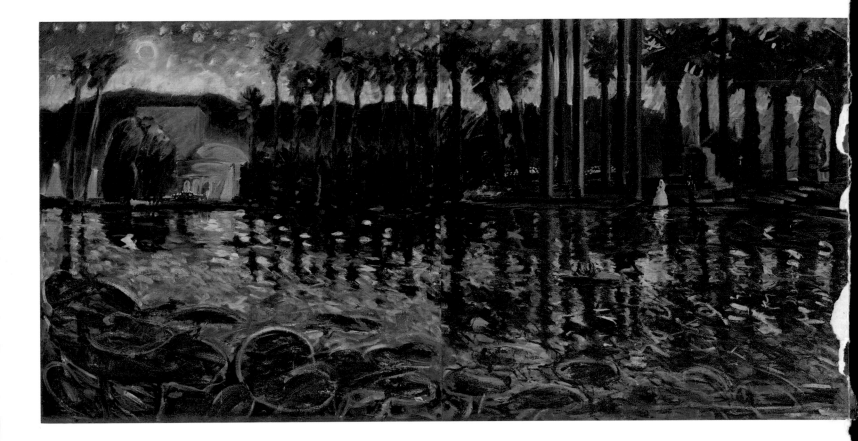

Love Makes The City Crumble, oil on canvas, 1983

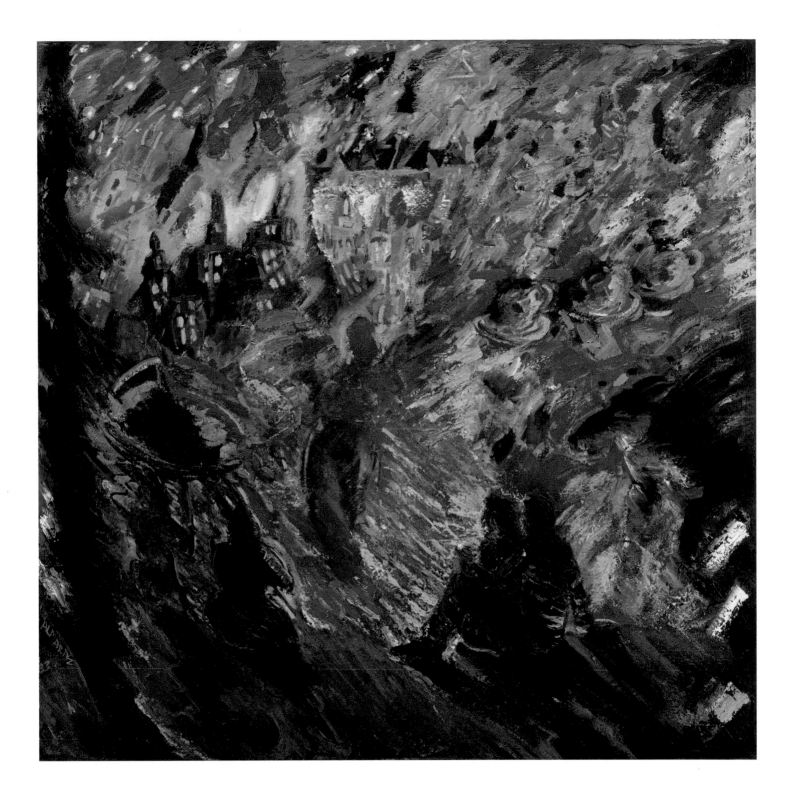

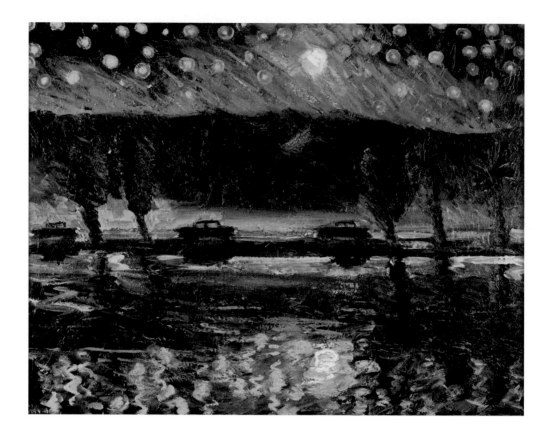

Starry Night, Echo Park, oil on canvas, 1984 *Bridge in Deep Magenta*, oil on canvas, 1984

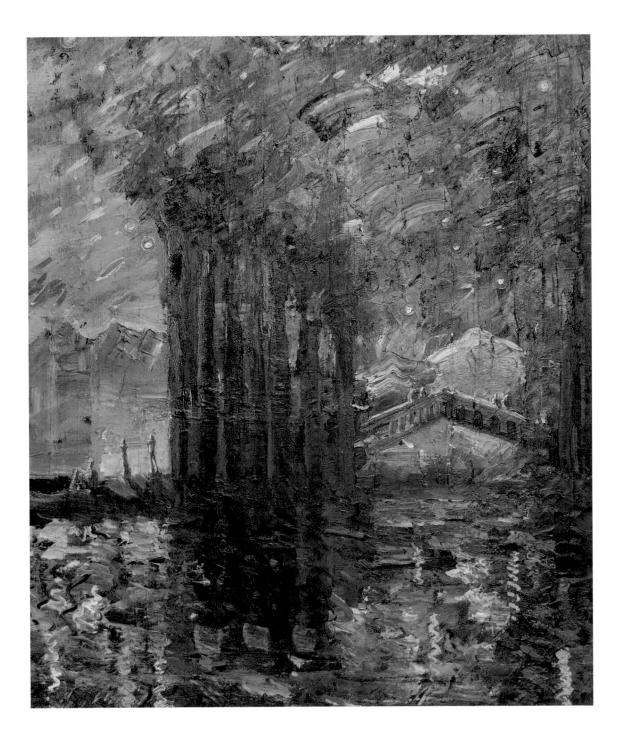

31

Tomorrow, oil on canvas, 1979 *Glendale Boulevard*, pastel on paper, 1979

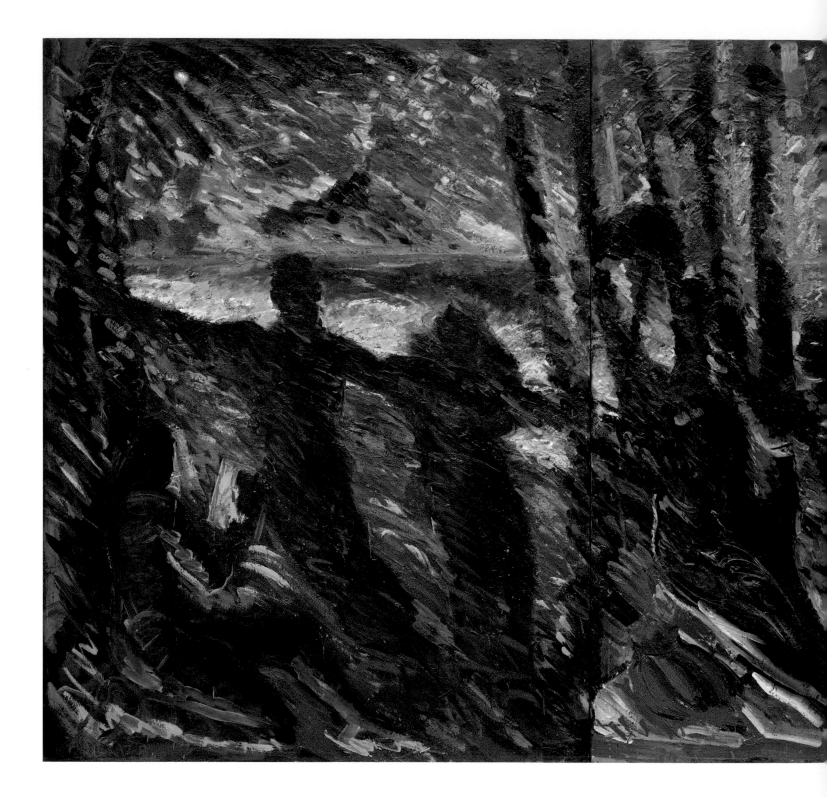

Early Hawaiians, oil on canvas, 1983

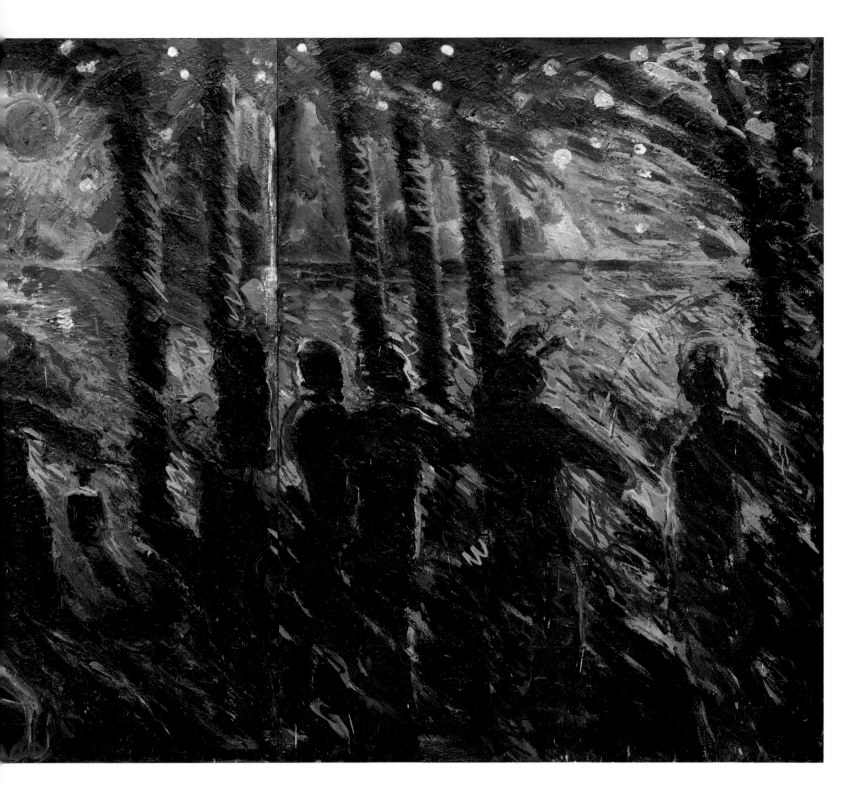

Kauai Nocturne, pastel on paper, 1983 *Hawaiian Nocturne*, pastel on paper, 1983

Bad News

Standing as the opposite of Almaraz's idylls are his many depictions of danger, disaster, and mortality. He is perhaps best known for his series of fiery car crashes—scenes of colliding automobiles, car explosions, and vehicles careening over the guardrails of elevated Southern California freeways. These pictures, such as *Sunset Crash* (1982), *Crash in Phthalo Green* (1984), and *Over the Edge* (1984), are spectacularly sumptuous images, rendered in tactile, buttery-thick impasto. They have darkly comic, even sardonic overtones: their improbable fusion of terrible human disaster with a slyly seductive visual command seems to relegate human suffering to an invisible afterthought, while instead we stare at the stunning visual beauty of these dreadful catastrophes.

The car crashes join other compelling scenarios such as runaway trains, houses on fire, and shootouts, reflecting aspects of real troubles plaguing Southern California during a time of turbulent social change. This is nowhere more hauntingly represented than in *Suburban Nightmare* (1983), which depicts a row of three identical tract houses, each with an identical car parked in front. The middle house is consumed by fire, the flames lighting up the night sky in a cataclysmic rage of color. Although it is possible to interpret the painting at face value, as a captivating picture of a burning house, it may also be viewed metaphorically, as the destruction of the (white) American Dream by forces beyond control. Almaraz's painting does not represent a changed neighborhood so much as the vulnerability of a cultural icon.[1] Less cataclysmically, *Chatita Kitty* (1989), painted in the artist's final year, illustrates the moment when a cat deposits a half-dead bird at its owner's feet. It is a true-to-life (and death) depiction, which Almaraz proffers as much as a fact of domestic life as one of undomesticated nature. In his art there can be an operatic drama even at the back door of a bungalow, as the family cat returns home.

1. See Howard N. Fox, "Many Californias, 1980–2000," in *Made in California: Art, Image, and Identity, 1900–2000* (Los Angeles: Los Angeles County Museum of Art, and Berkeley: University of California Press, 2000), 247–48.

Crash in Phthalo Green (detail), 1984

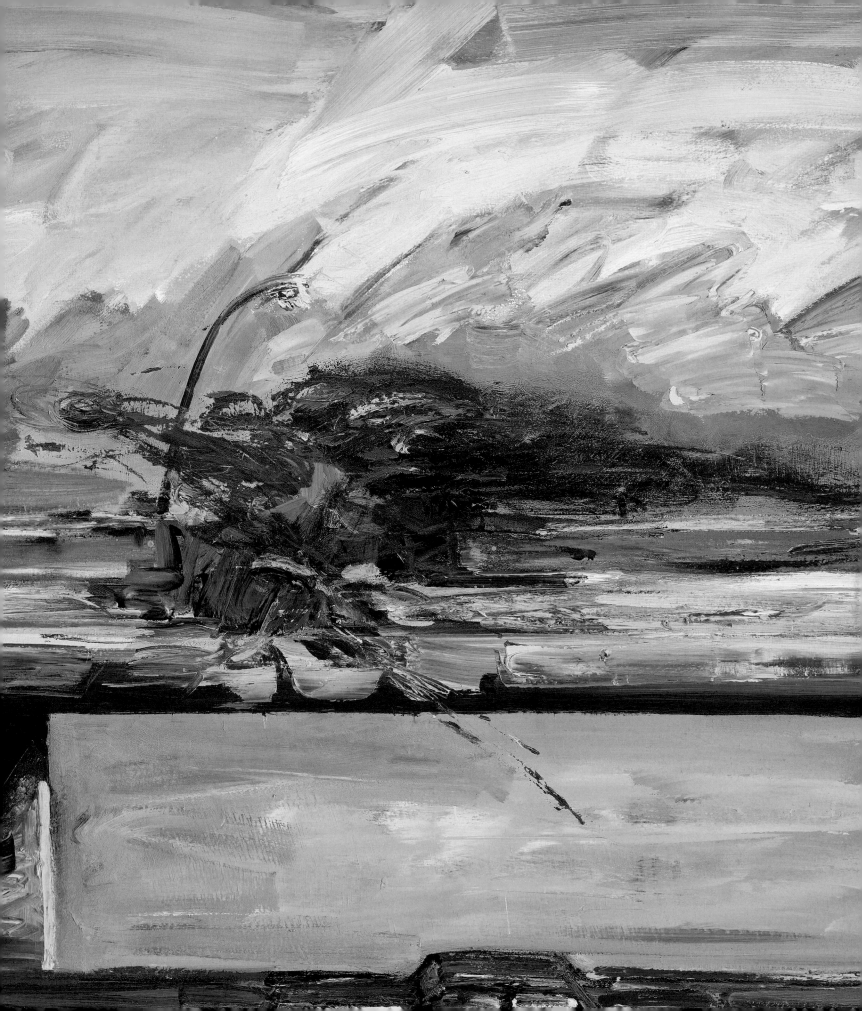

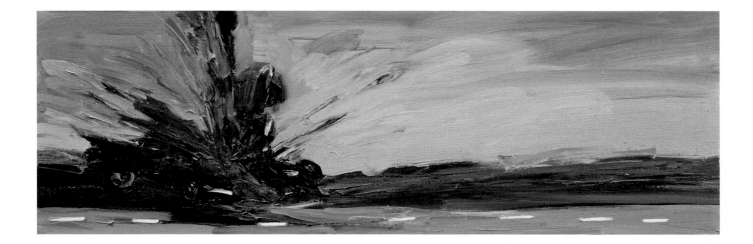

Perpendicular Crash, oil on canvas, 1985 *Sunset Crash*, oil on canvas, 1982

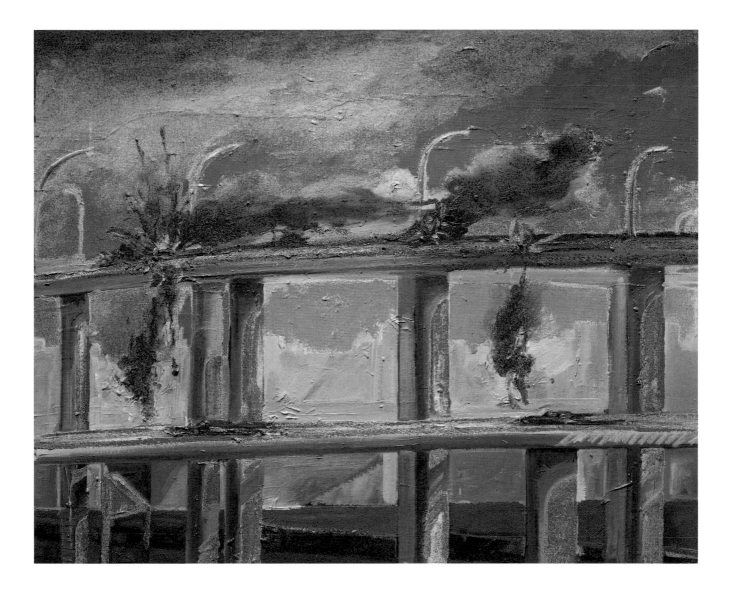

Over the Edge, oil on canvas, 1984

West Coast Crash, oil on canvas, 1982

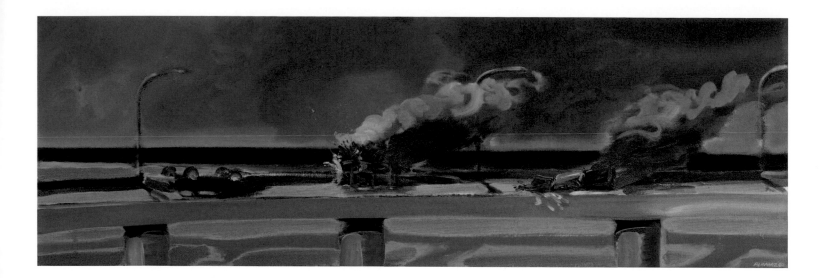

Longo Crash, acrylic on canvas, 1982

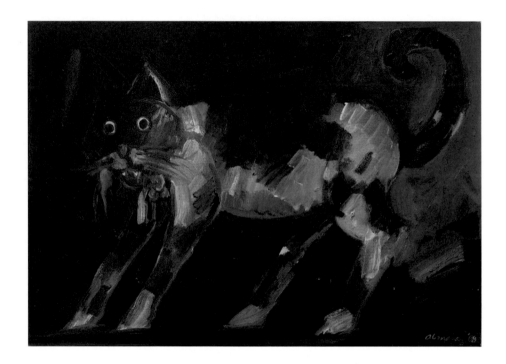

Chatita Kitty, oil on canvas, 1989 *Greed*, oil on canvas, 1982

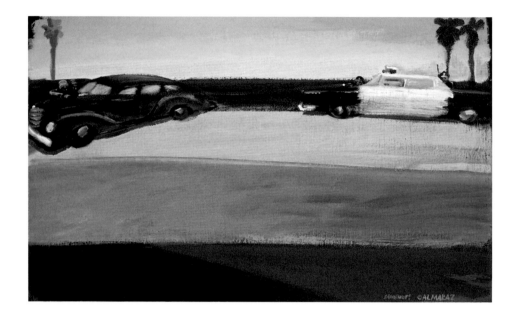

Shoot Out, acrylic on canvas, 1978 *Murder,* oil on canvas, 1987

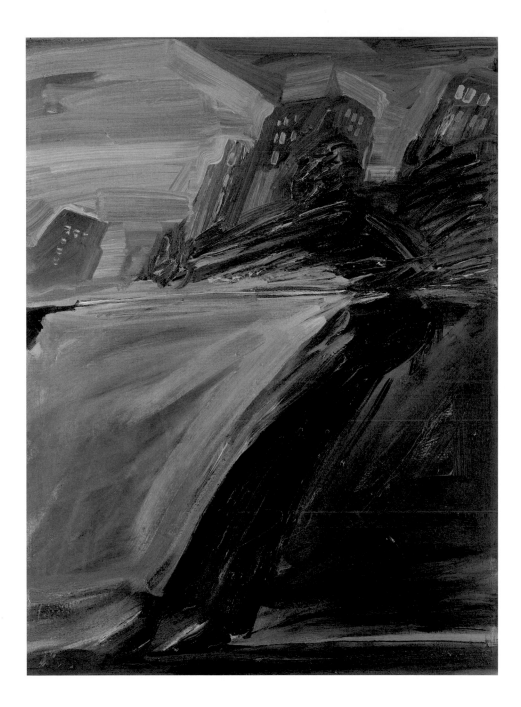

Domesticity

Some of the warmest visions that Almaraz presents are scenes of home, where we enjoy creature comforts, where we see out solitude or intimacy, where we return to renew ourselves psychologically and physically. *The Red Chair* (1980) is a simple picture of an unoccupied room in an old bungalow showing only a dilapidated, overstuffed red velvet easy chair and an end table with a lamp; it is a domestic still life as banal as they come, but simultaneously it is so saturated with a richness of colors—ocher, vermilion, lavender, moss, spruce—that the room becomes animate with implicit life and spirit. The spatial vacancy is haunted by a narrative of untold possibilities: comings and goings, quiet sojourns, noisy altercation, tranquility, anxiety. In the background we glimpse the artist's wife holding their baby. This painting is the loving reflection of a husband and father on the fulfillments of his daily life at home.

Among Almaraz's most enigmatic paintings is *Rocking the Baby* (1983), an image of two seated figures—a mother holding an infant, perhaps breastfeeding, and (presumably) the father in a second chair. The parental figures are surrounded by a swirling and ambiguous visual tableau: to the left of the couple a figure rides a horse in front of a male wearing a cowboy hat, as the moon glows in the night sky above them. On the right, several trotting figures carry umbrellas (another recurring motif, perhaps suggesting individuals taking defense from menacing circumstances, whether external or internal), while above the couple a group of mysterious corporeal beings, including other umbrella-bearing souls, are pursued by a horned animal that echoes the trickster seen in other works by Almaraz. The baby—the ostensible subject of the opus—exists, as do all offspring, amid a world of strange and unpredictable possibilities. This portentous painting evokes the imaginable gamut of incidents and destinies that any of us might encounter in life, and yet which is utterly uncertain to each of us.

Domestic Icons (detail), 1981

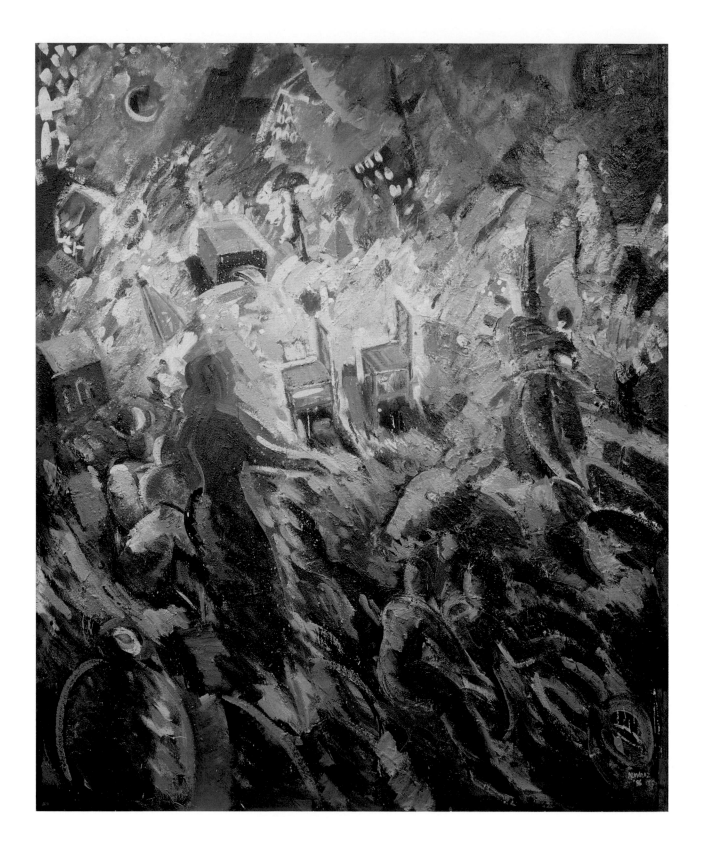

The Two Chairs, oil on canvas, 1986 *Domestic Icons*, oil on canvas, 1981

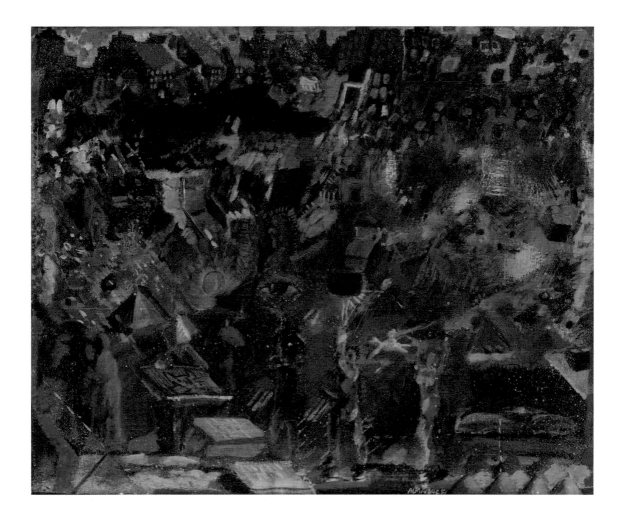

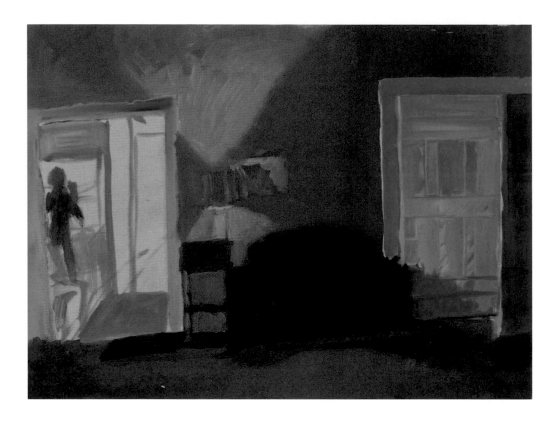

The Red Chair, oil on paper, 1980 *Rocking the Baby*, oil on canvas, 1983

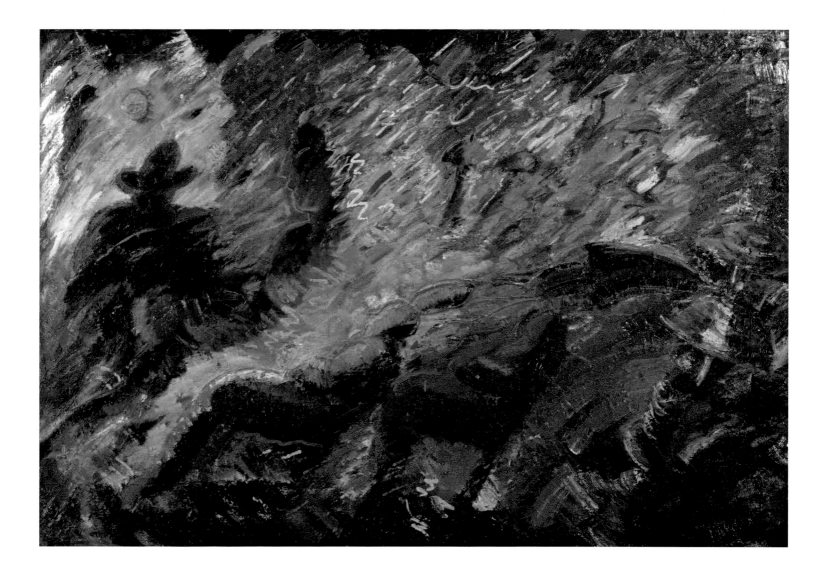

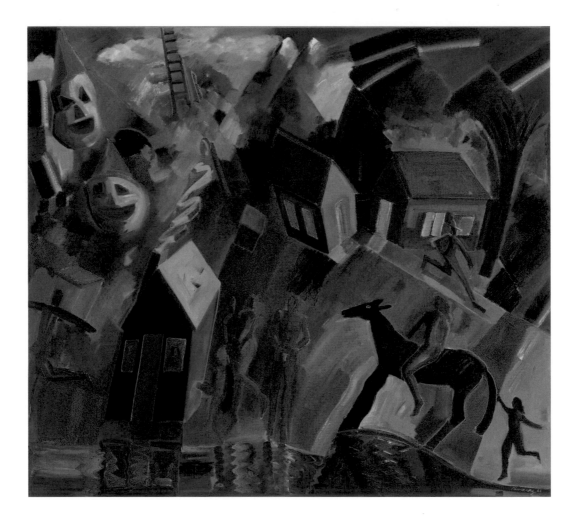

House Motif, oil on canvas, 1988 *School Days*, oil on canvas, 1988

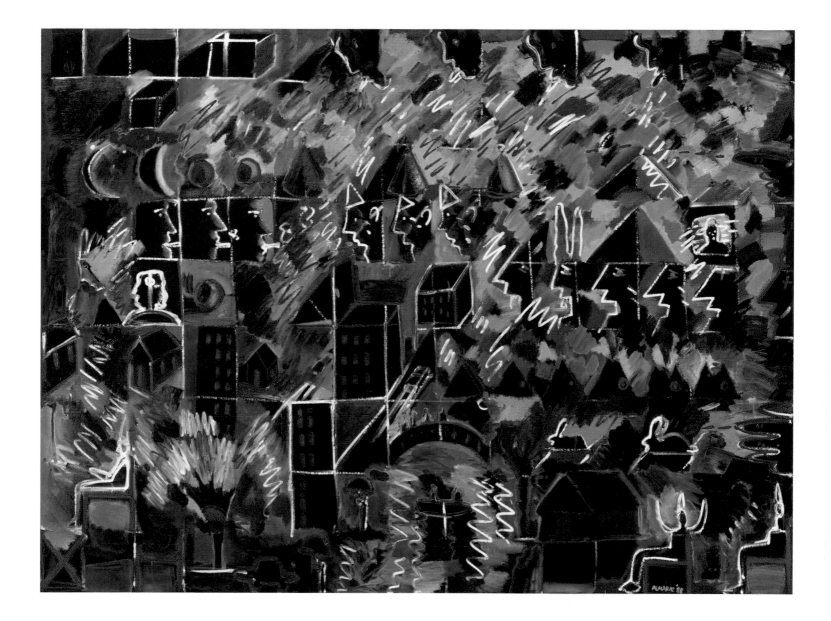

Sexuality and the Erotic

Sexuality figures into many of Almaraz's works, sometimes symbolically or suggestively, and sometimes openly and explicitly. His ink drawing *The Muffing Mask* (1972) presents a devil-masked male figure performing oral sex on a female figure. It is likely that he intended this work not as titillating but rather as a matter-of-fact depiction of sexual activity, albeit with a dash of Rabelaisian wit in the devil mask. *Siesta* (1972), another ink drawing, features two men resting in bed, presumably after sex. *The Struggle of Mankind* (1984) presents a pair of naked male wrestlers in an image highly suggestive of homoerotic engagement.

These works of Almaraz's evince his openness, starting in the 1970s, to explore sexual themes and sexual fluidity at a time when doing so was simultaneously rather daring yet also becoming a sociocultural inevitability. Although they have not previously been exhibited, Almaraz's depictions of sex anticipated a time when such imagery would no longer cause a public or political uproar.

The Struggle of Mankind (detail), 1984

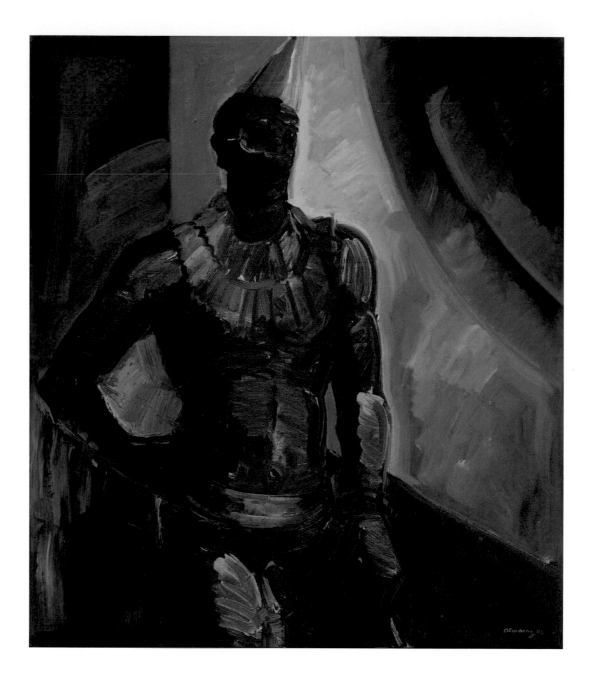

Naked Jester, oil on canvas, 1988 *The Struggle of Mankind*, pastel on paper, 1984

Siesta, ink and watercolor on paper, 1972 *That Guy*, oil on canvas, 1983

Frenzied Fantasies, ink and watercolor on paper, 1972 *The Muffing Mask,* ink on paper, 1972 *Big Bang,* ink and watercolor on paper, 1971

Dreams and Allegories

Shadowy humanoids, animals, and mythic figures populate Almaraz's most enigmatic and haunted works, some of which take place on a proscenium stage, while others transpire in an ambiguous dream space or a Hades-like underworld. Ambiguity and mystery prevail, while a sense of "something other" animates these tableaux. Among the earliest of Almaraz's psychologically unsettling paintings is *Abajo del agua (Under the Water)* (1980). A body of water shimmers on its surface, but is inhabited by monstrous aquatic life forms below: toothy killers, blob-like gelatinous creatures, tentacled marauders. Even without a narrative, Almaraz's vision represents anyone's nightmares of their worst fears, real or imagined.

The tableau in *Europe and the Jaguar* (1982) is dominated by a female nude, a man in a suit and brimmed hat, and a bright orange half-man/half-jaguar figure walking upright on two legs, his tail flourishing behind him. He appears to stride into the picture directly from ancient Mesoamerican mythology and art, which Almaraz had studied extensively. This jaguar-man appears in numerous Almaraz works and is an analogue to the masked figures in his art, one of many shapeshifters and, frequently, mischief-makers. There is no specific narrative in *Europe and the Jaguar*, but the universe it reveals is one of crossing over, of dislocations and relocations in time and space. *City Jaguar* (1988), a closely related work, sets a monumentally scaled jaguar-man in the foreground against a delirious cityscape that pushes against the top edge of the canvas, as if trying to break through into the "real" world.

In contrast, the central image in *Tree of Life* (1987) is a blue tree surrounded by an array of figures, including a woman serving a goblet of wine, a man wearing only a hat and briefs, and a harlequin figure. At the very bottom of the picture, almost as if it were a visual rivet tying everything together, is a death's head. The composition is a joyous declaration of lively existence, with a *memento mori* at its emotive nexus. The harlequin appears as well in *Buffo's Lament* (1987), a disguised self-portrait in which the stock character from Italian comic opera is shown isolated and alone.

Deer Dancer (detail), 1989

Abajo del agua (Under the Water), pastel on paper, 1980 *Europe and the Jaguar*, oil on canvas 1982

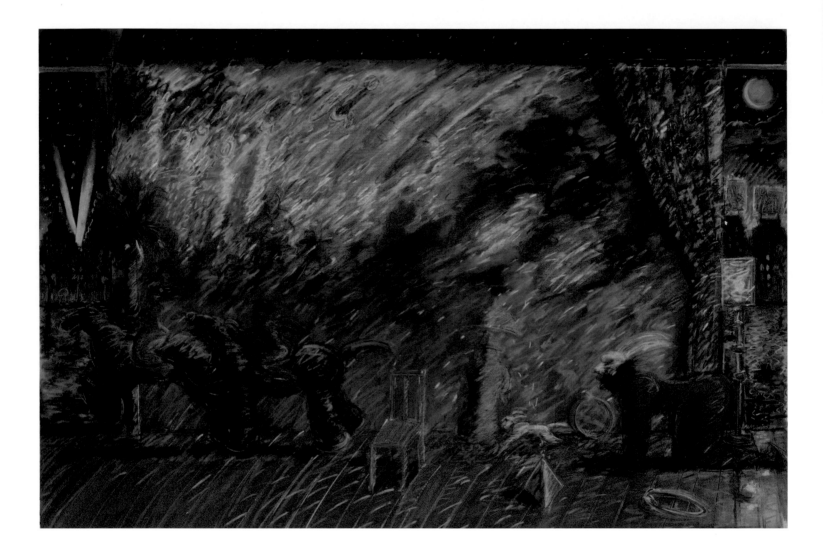

Night Theater, pastel on paper, 1984 *City Jaguar*, oil on canvas, 1988

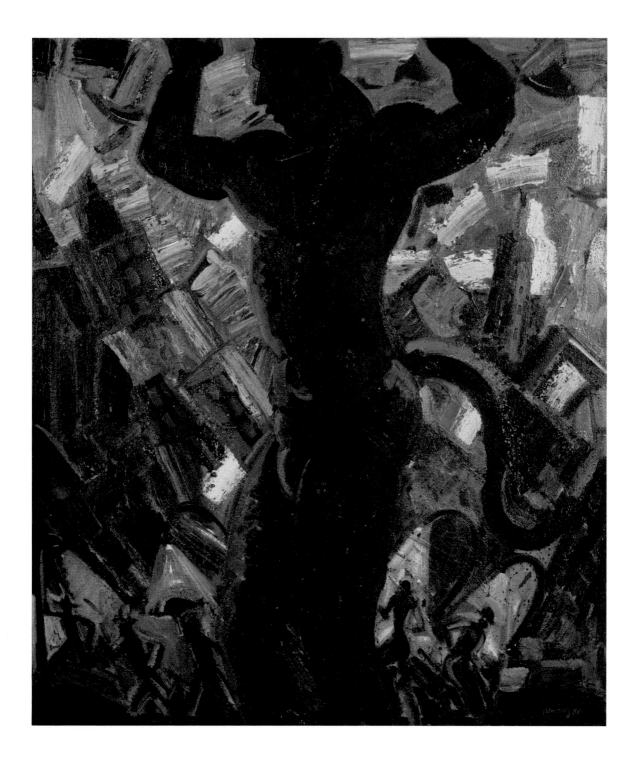

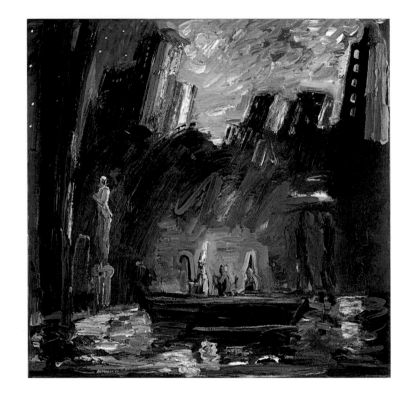

The Crossing, oil on canvas, 1986 *Tree of Life*, oil on canvas, 1987

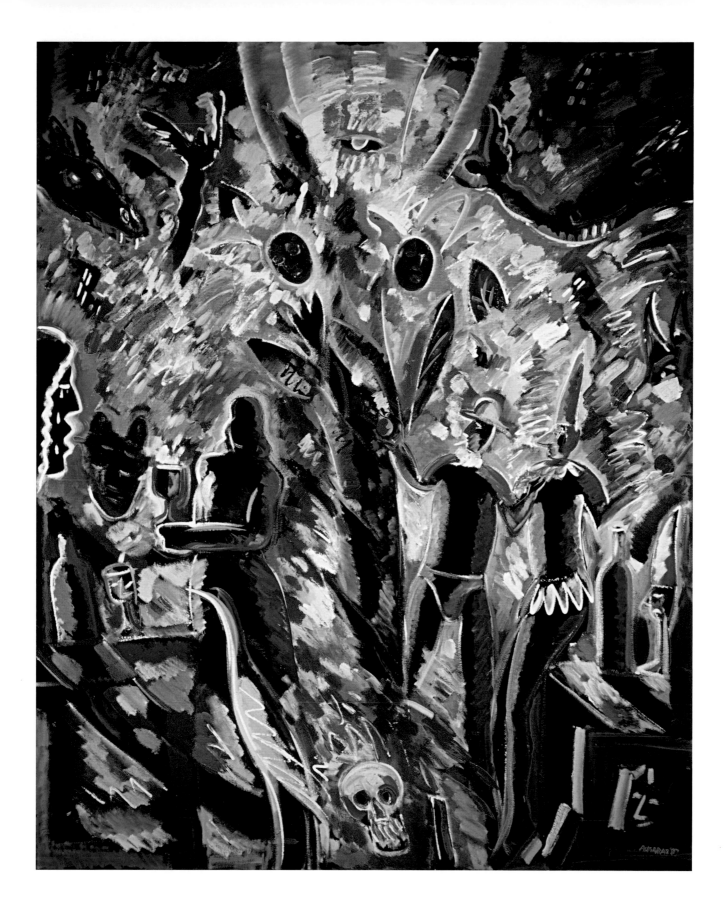

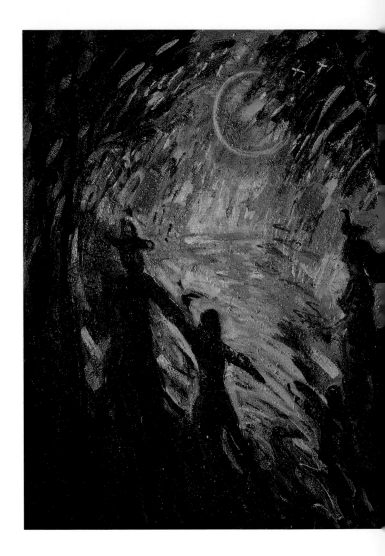

Mito de luz de luna (Moonlight Myth), oil on canvas, 1985

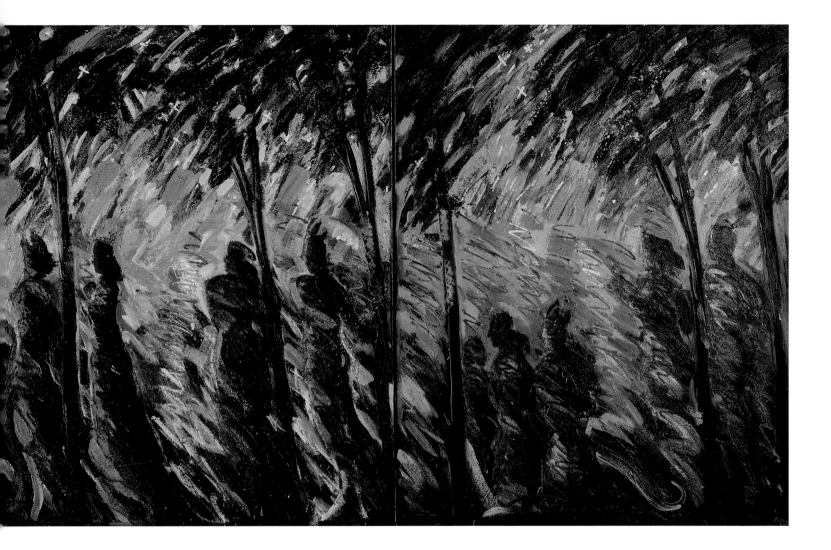

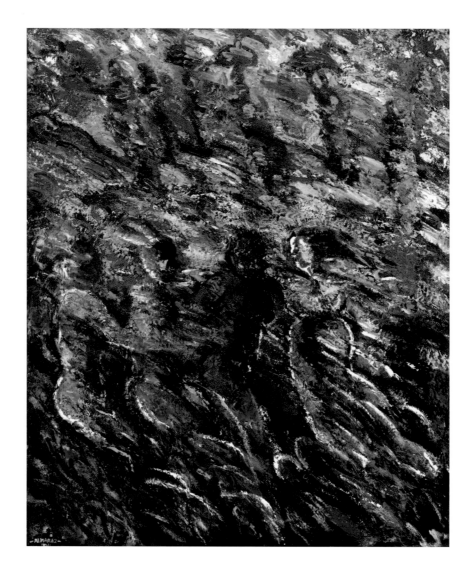

Creatures of the Earth, oil on canvas, 1984 *The Gods Who Found Water*, oil on canvas, 1984

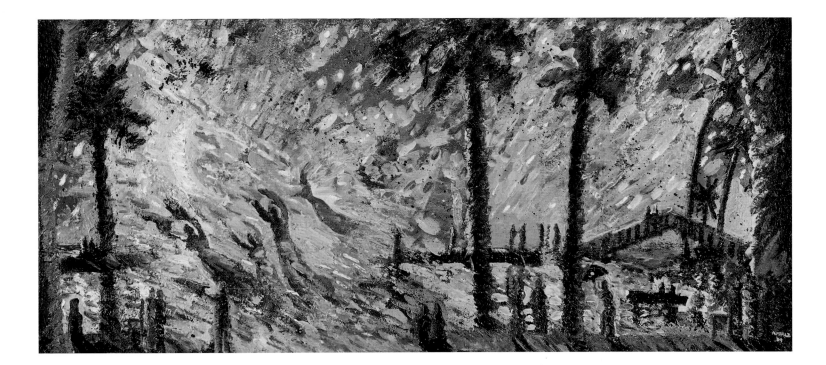

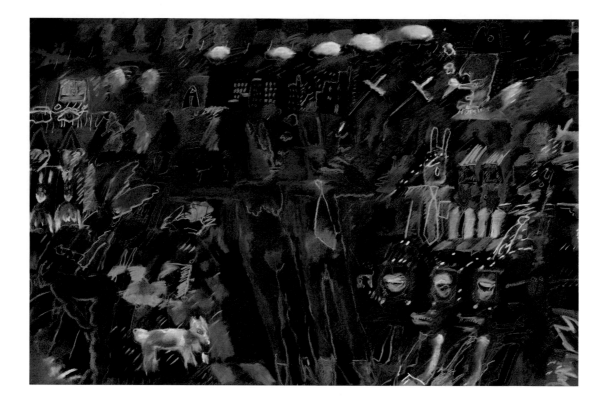

Mr. and Mrs. Rabbit Go to Town, pastel on paper, 1982 *The Eternal City*, oil on canvas, 1986

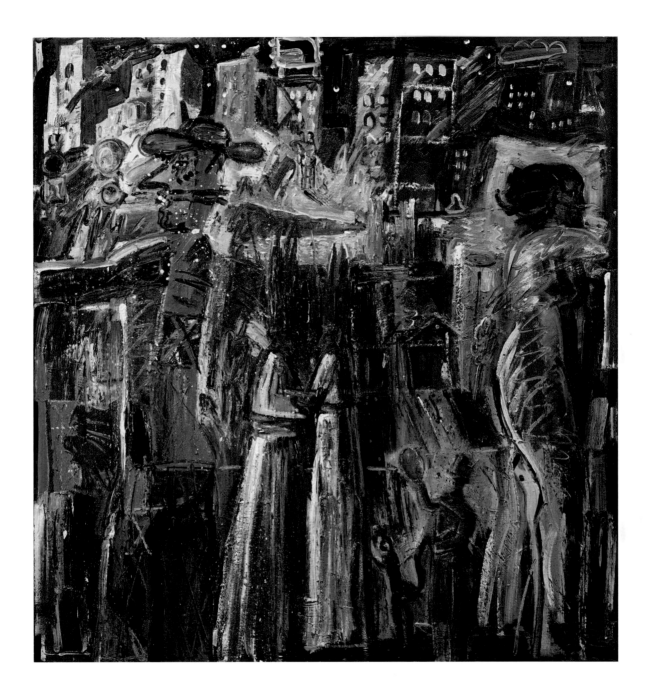

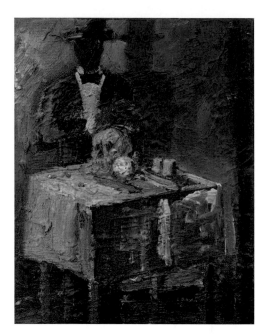

The Magician, oil on canvas, 1987

The Magician, oil on canvas, 1987

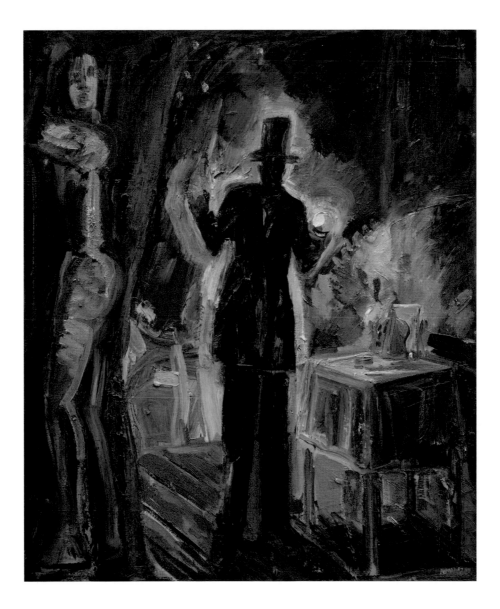

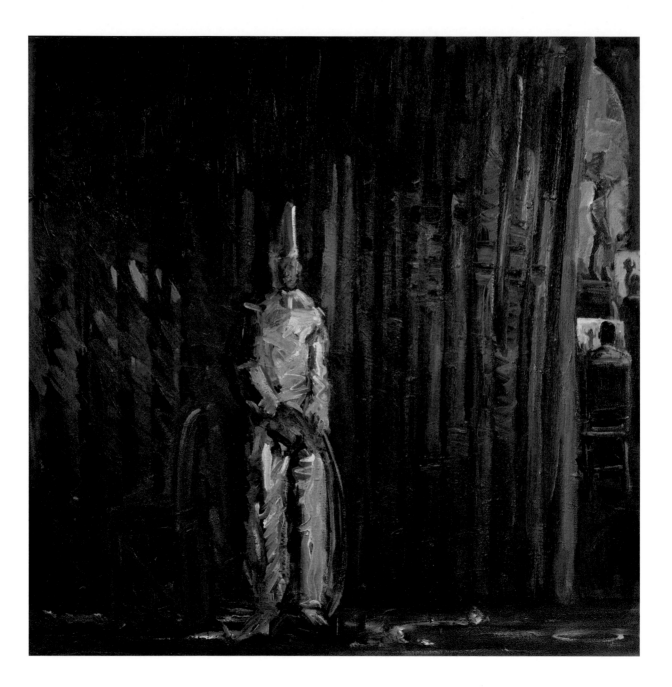

Buffo's Lament, oil on canvas, 1987 *The Conjuror's Power of Suggestion,* acrylic on canvas, 1972

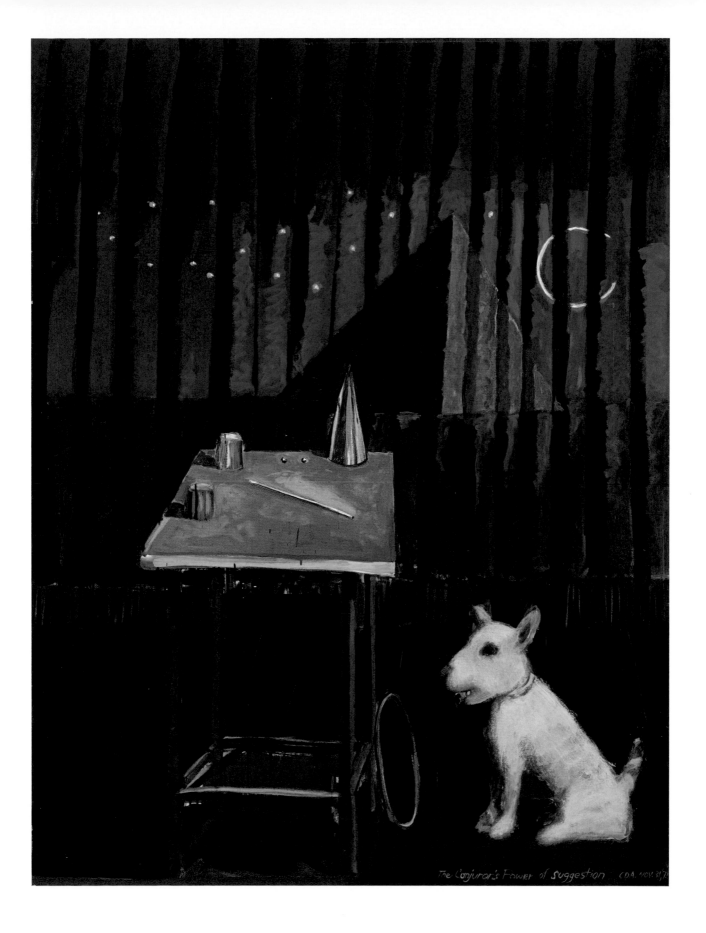

The Conjuror's Power of Suggestion C.D.A. Nov. 21, 7?

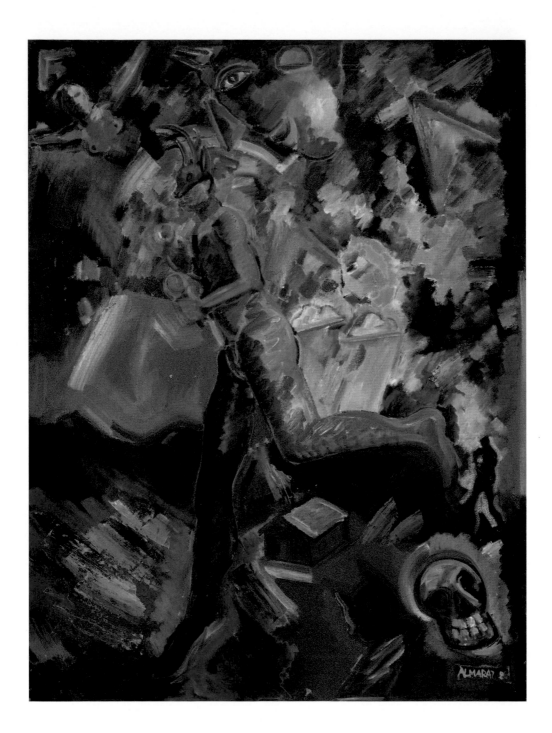

Deer Dancer, oil on canvas, 1989

Magic Green Stage, oil on canvas, 1982

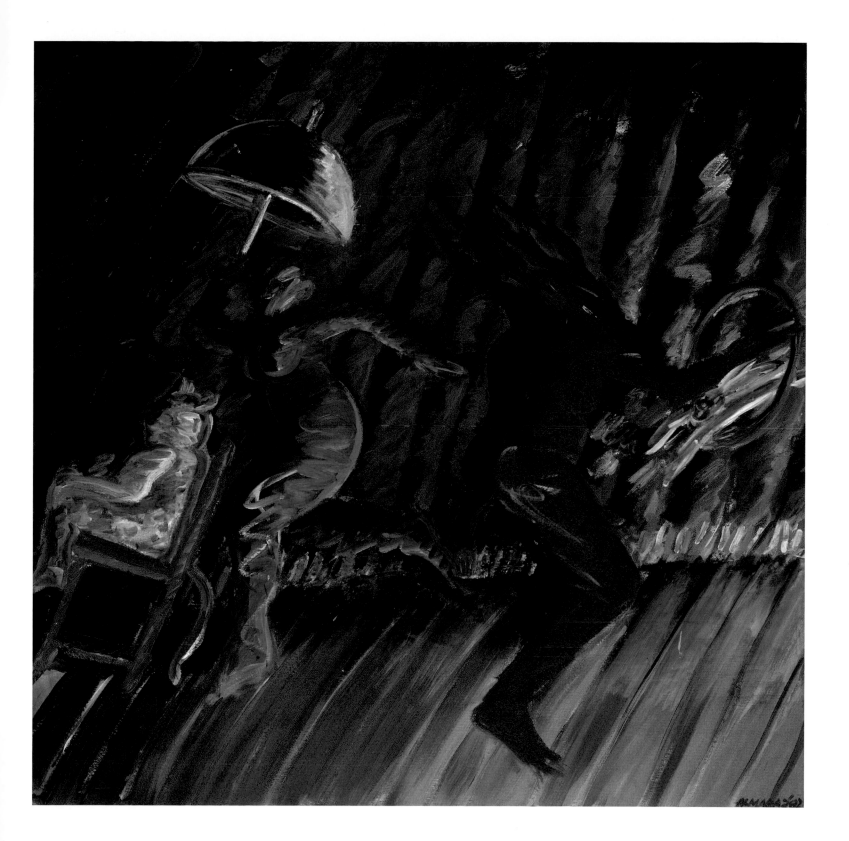

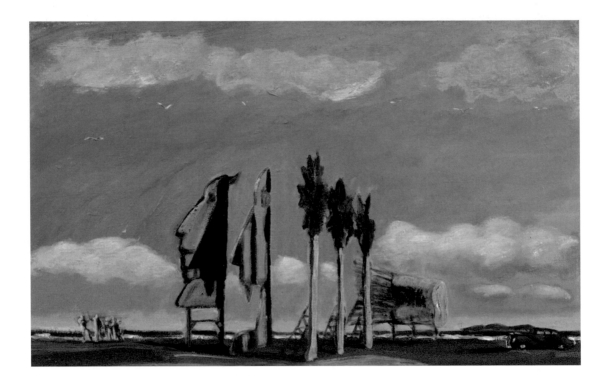

Hollywood Saga, acrylic on canvas, 1980 *La Llorona de los Siglos (The Weeping Woman)*, acrylic on canvas, 1973

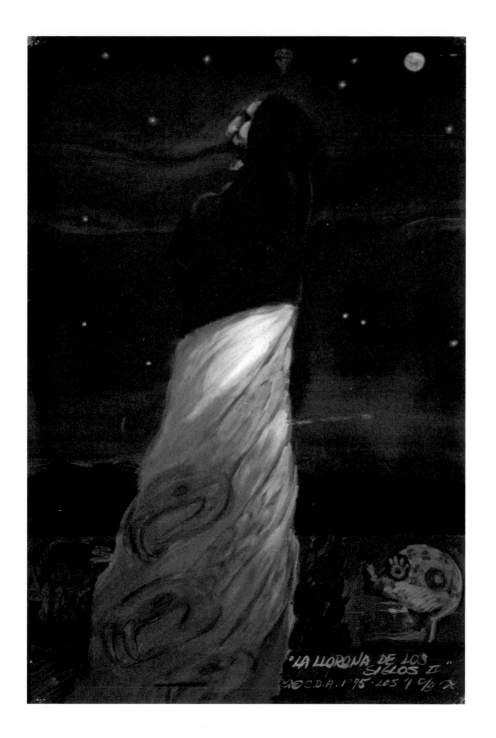

Yellow Morning, oil on canvas, 1986

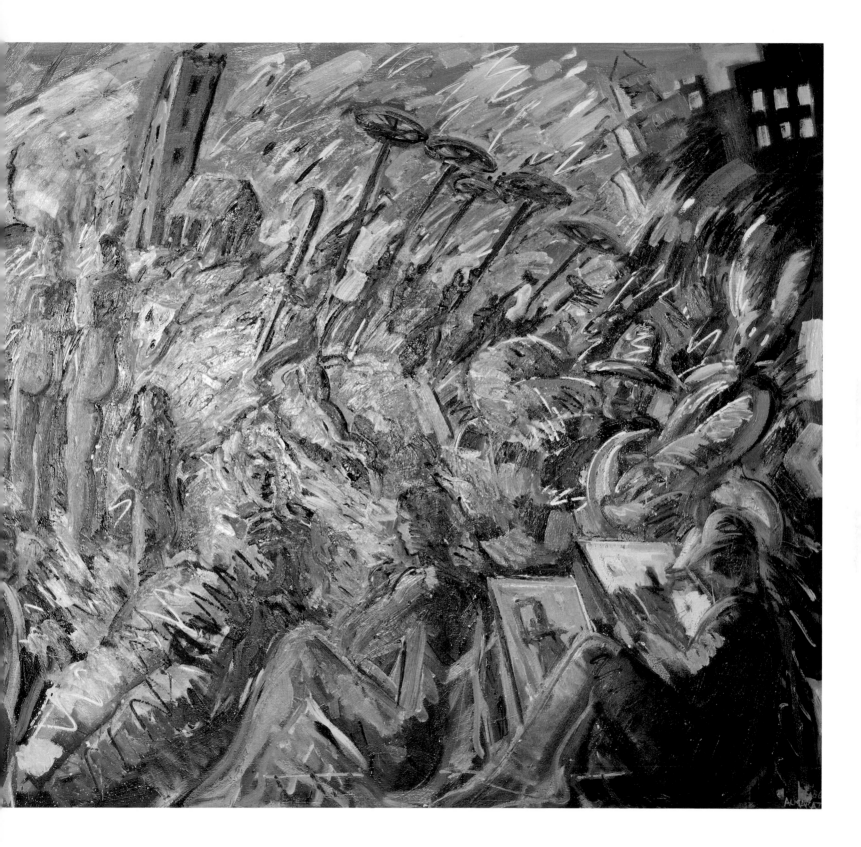

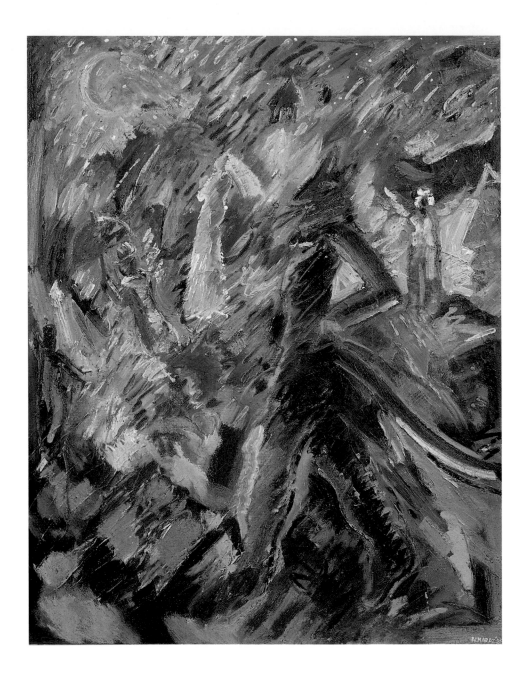

Cat Man's Wedding, oil on canvas, 1985 *Two of a Kind*, oil on canvas, 1986

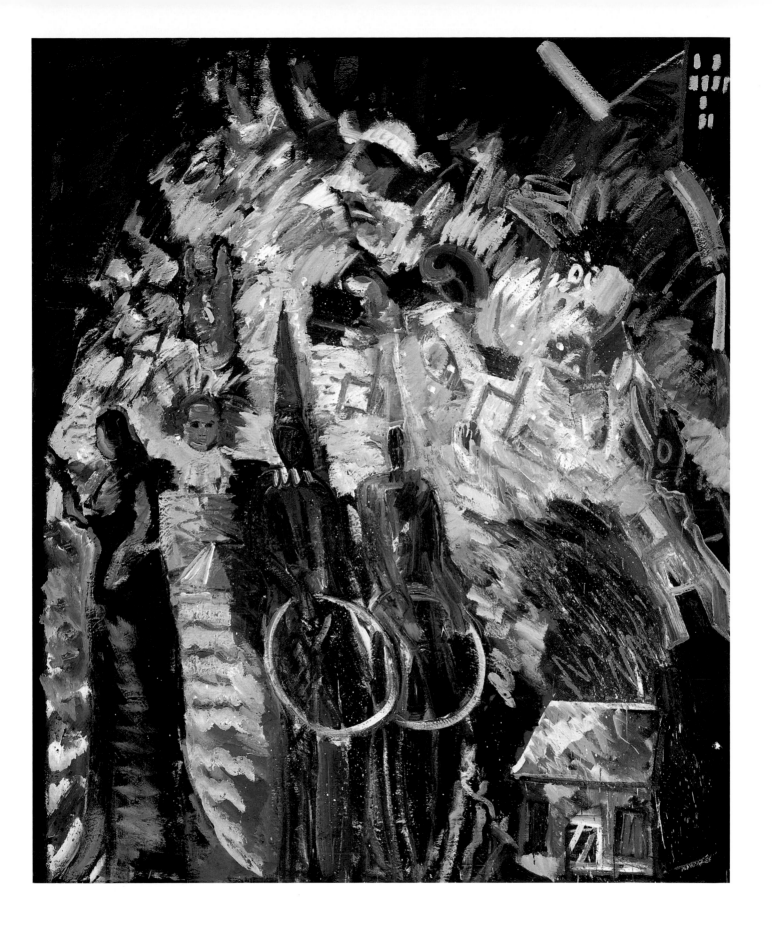

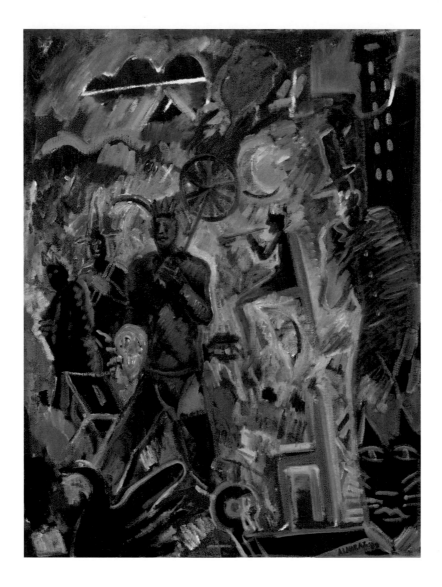

Return of the King, oil on canvas, 1989

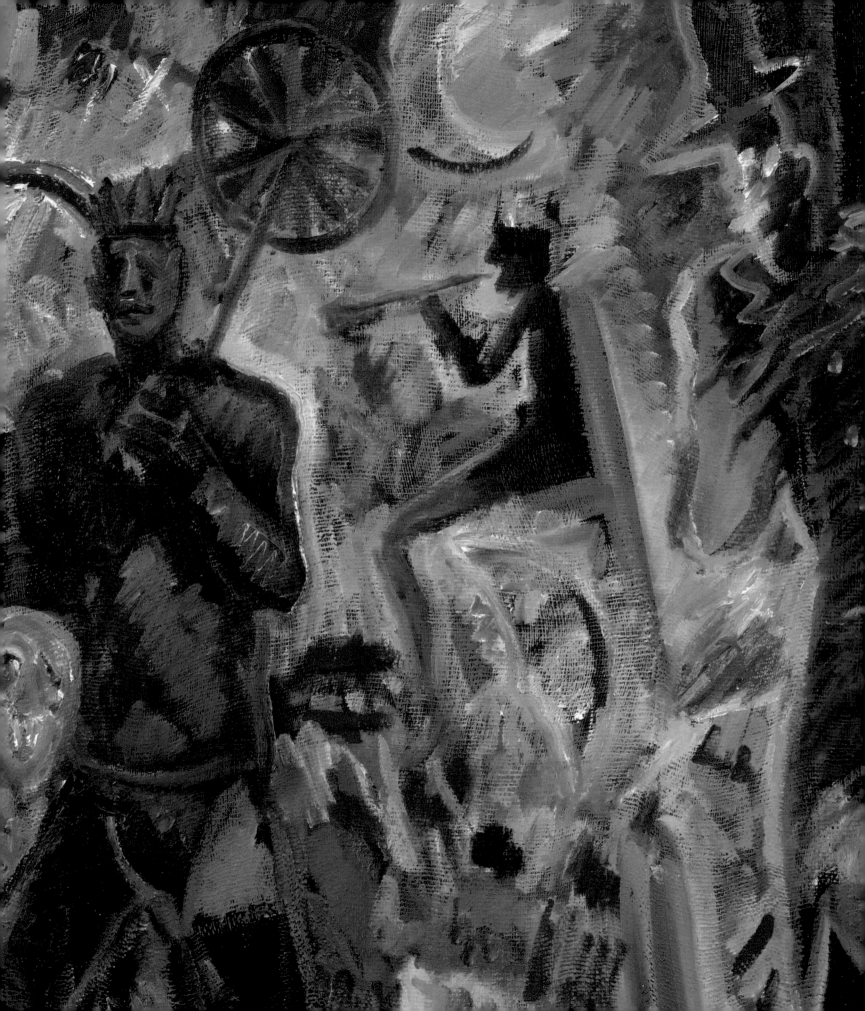

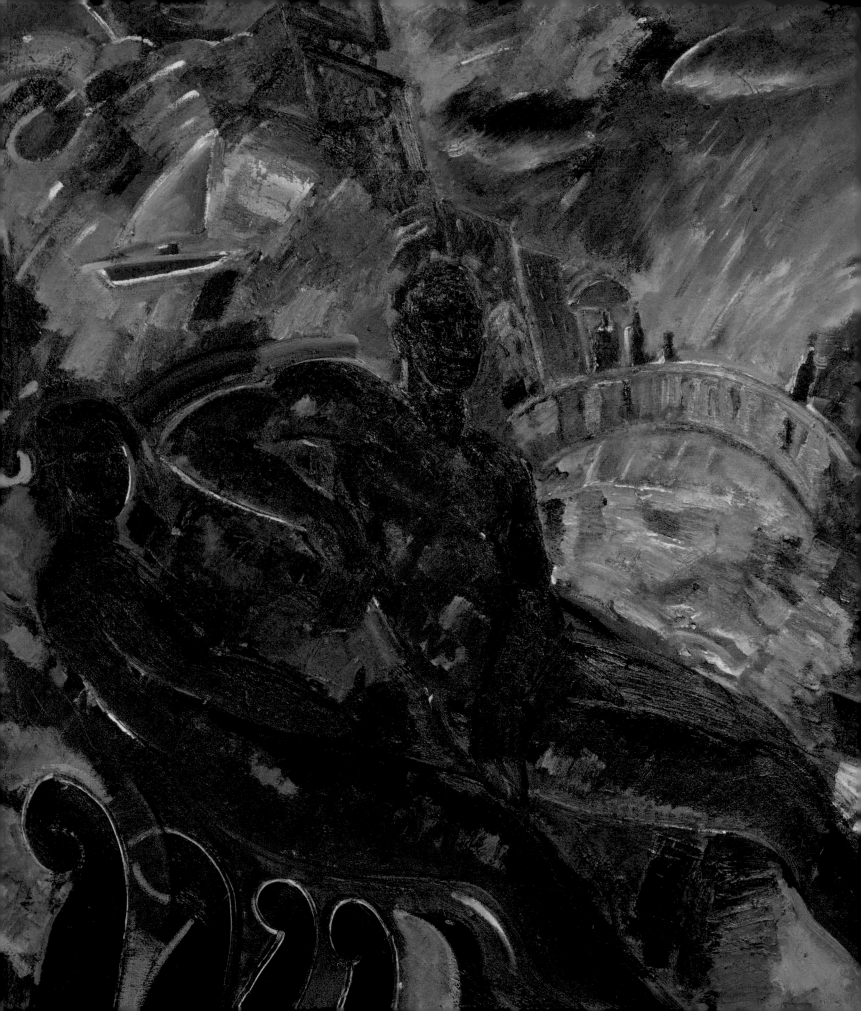

The Artist's Journey

The Life and Art of Carlos Almaraz

Elsa Flores Almaraz
with Jeffrey J. Rangel

Carlos David Almaraz died twice in his lifetime. His first death occurred in 1971, when he spent forty-five days at the Los Angeles County General Hospital battling pancreatitis. When he finally succumbed to HIV/AIDS in 1989, death was no stranger to him. His experiences had taught him not to fear death, but to walk alongside it. Over the course of his lifetime he underwent a series of personal deaths and rebirthings—dying into himself to be transformed into new incarnations as a man, an artist, and a seeker of personal truths. Carlos willingly entered the inner territories of the unknown to wrestle with his demons in order to cleanse himself and be reborn.

Even his early years were characterized by change. He was born in Mexico City on October 5, 1941, to Rudolph and Rosa Almaraz. The family traveled from Mexico City to Morelia, Michoacán, and then to the United States, settling first in Indiana and Chicago before eventually migrating to Southern California. The family grew and by the time they settled in Southern California, Carlos had two brothers, Rudolph Jr. and the baby, Ricky. (Fully assimilated into the American experience, the senior Almaraz changed Carlos's name to Charles at a young age; he would return to using Carlos during his cultural rebirthing in the 1970s.) He was ten years old when they made the long train ride from Chicago to Los Angeles—a ride that would resurface among the many personal iconographic images in his work. On arrival, Carlos noticed the color of Southern California—that special quality of light. The scent of jasmine and orange blossoms hung sweet and pungent in the air. He recalled the tall palm trees swaying as the warm Santa Ana winds embraced them when the train first pulled into the station. He felt like he had finally come home.

California Natives (detail), 1982

TOP: Almaraz family portrait, 1940s
BOTTOM: Dan Guerrero (left) and Carlos Almaraz, 1950s

The Almarazes eventually put down roots on McDonnell Avenue in the Mexican enclave of East Los Angeles. As a boy, Carlos's sharp wit, intelligence, and charisma quickly set him apart. He spoke differently, knew more about the world than many of the other kids, knew that he wanted to be an artist. He befriended Dan Guerrero, the son of local Latino musical star Lalo Guerrero, and the elder Guerrero further exposed Carlos to the world of arts and entertainment. But though Carlos had a glowing confidence, he would grapple with childhood fears and demons throughout his lifetime. The earliest of these demons dates back to Mexico City, and involves a church depiction of John the Baptist in the Metropolitan Cathedral, which was so hairy and covered in furs that Carlos believed it to be a gorilla and became terrified of attending church with his mother and grandmother. The power of the archetype was etched into his psyche, one of many that he would successfully access in his work decades later.

But the most powerful fear, and the one that remained with Carlos throughout his life, was based on the unconscionable reality of sexual abuse: first as a young boy at the hands of a pedophile uncle, and later during his adolescence by a local Catholic priest. These experiences of sexual abuse would greatly impact his sense of sexual identity, spinning him into a lifelong search for answers and would infuse his work with the passion and raw edge of intensive internal explorations. That exploration would be the key to his personal liberation.

One of the most significant steps Carlos took in enacting change in his life came on Valentine's Day, 1962, when he and Guerrero boarded a plane for New York and arrived in the middle of a seemingly magical snowscape: "I remember best that [taxi] ride through Central Park…. It was like in slow motion, just driving. You couldn't believe that it was there and it was magnificent. Dorothy walking into Oz must have felt the same way," Guerrero recalled years later.[1] For Guerrero, New York represented the prospect of a life in the theatre. Carlos accompanied him as a fellow adventure-seeker intent on exploring the possibility of living as an artist in the art capital of the world. Carlos returned to Los Angeles six months later to take advantage of a scholarship that awaited him at the Otis Art Institute, ultimately earning his degree and the respect of his teachers and peers alike at Otis. During this three-year period, he became convinced that if he was to lead the life of a serious artist, he would have to return to New York. In 1965, he once again made the trip back East. Once in New York, he fortuitously happened into renting a Soho loft near Chambers Street from artists Richard Serra and Nancy Graves.

Life in New York was experimental and exploratory, and its distance from home afforded the twenty-four year old unprecedented opportunities to fashion his identity.

Intellectually, Carlos was a voracious reader, an astute student of psychology, art history, literature, and French. Unbeknownst to his friends and family back in L.A., Carlos engaged openly in relationships with men in New York. But his history of abuse surfaced in his penchant for extremely risky behavior, leading him to indulge his self-destructive side through alcohol and sex in bathhouses and public parks as he burned through a series of toxic relationships.

While his social and intellectual selves were guided by his own inner voices, his artistic development was marked by a degree of conformity. He struggled to fit within the parameters of the prevailing minimalist, hard-edge aesthetic and received little critical or commercial recognition for his efforts. Nonetheless, he pursued his art with passion. He took to developing a series of grid pieces executed in graphite, filled with geometric shapes and abstract designs and, every once in a while, a smooth organic line. They were meditative works in which the structure and repetition, the simplicity of the materials, allowed him into his subconscious, an arena in his art making that had been blocked by the abstract minimalist art movement of the time. What surfaced were the first inklings of Carlos's imagistic, primitive alphabet through which he would try to construct a universal language. Unknown even to himself, he was laying the technical and compositional foundations for his most accomplished expressions later in life.

Nevertheless, his work became labored and less enjoyable; in combination with a series of troubled romantic relationships and an increasing confusion about his bisexuality, Carlos was sent into a deep depression that he attempted to medicate through alcohol. Things got so difficult that he committed himself into the Mt. Sinai Psychiatric Ward twice in 1968. His stays at the hospital were an acknowledgment of his fragile mental state, but more than anything they provided a respite from the everyday; a chance to stop, rest, reflect, and gather himself together. Looking for fresh experiences and a change of scenery after his release, Carlos hopped a freighter to Africa and over the course of several months made his way through Spain, France, Belgium, and England. Carlos absorbed the work of the European masters, spending countless hours in museums and galleries.

His travels were artistically formative, but not enough to shake him of his depressed moorings in New York. His drinking grew heavier, and as he drank he became surlier and more troubled in his romantic life. Art making had all but ceased. While in Europe, Carlos contemplated a return to Los Angeles; though it felt like admitting defeat in terms of attaining his life's vision, it was home and it would certainly simplify life. Rather unceremoniously, like a prodigal son with nobody to receive him, Carlos returned to Los Angeles on New Year's Day, 1970. He settled back at his parents'

TOP: *N.Y. Abstract Pastel*, 1969
BOTTOM: Page from Mt. Sinai sketchbook, 1969

Page from sketchbook, 1971

house on the East side, showing his work locally in a few group exhibitions and traveling back and forth between L.A. and New York. His drinking binges—often precipitated by fights with his romantic partner at the time—culminated in February 1971, when he nearly drank himself to death before being rushed to the emergency room of the Los Angeles County General Hospital in Lincoln Heights.

Carlos was hospitalized for more than six weeks for treatment of acute pancreatitis, floating in and out of consciousness for much of the time and having gone temporarily blind. At one point he regained consciousness just in time to witness a priest at the foot of his bed anointing his feet with oil for his last rites after his family had been told he had little chance of survival. Later, he would recall the experience of witnessing himself hover over his own lifeless body and looking into a tunnel of white light—a feeling so peaceful and beautiful that he wished not to return to his body, saying later that "death was sublime, I have no fear of dying now." Nevertheless, he clung to life.

This was followed by a second out-of-body episode. It happened one day when his heart rate had slowed to an almost imperceptible pace. He encountered what he perceived to be intelligent beings from another dimension; they whisked him off to tour the universe, after which he was given three choices in terms of how he could return: as himself, as a newborn baby, or as a figure he described as an "old black man" named Charlie. Carlos reported that he never felt threatened by the presence of these beings—on the contrary, he intuited that they were there to assist him in some unforeseen way. While still hospitalized, he regained enough strength to pick up a sketchbook and document his incredible travels, producing a series of detailed drawings depicting the beings and notes of what he had learned.

Carlos left the hospital a changed man, feeling reborn and determined not to return to New York or to alcohol. Though he was still battling a sense of failure, his spirt was renewed by once again living close to family and friends. Before his return, Carlos had been immersed in a self-contained world revolving around his art, relationships, therapy, and living as a New Yorker. Except for a general knowledge of current events, politics were an afterthought. But he soon encountered Mexican-Americans who were active in the free speech, antiwar, and black Civil Rights movements. He learned about high school students in East L. A. who had walked out of school in protest of inadequate conditions and opportunities, and his uncle, union organizer Ruben Alaniz, first educated him about Cesar Chavez, the charismatic labor leader who was organizing farm workers in California's Central Valley. Carlos was catching wind of the Chicano movement.

At first he was ambivalent toward the movement—even dismissive. It was his

interaction with artist Gilbert Luján that first drew him into the Chicano scene. "Magú," as he was known on the streets and in arts circles, was an ex-Navy boxer who was completing his MFA at the University of California, Irvine. He was also an editor for the influential Chicano arts magazine, *Con Safos,* a publication that offered "reflections of life in the barrio" and featured some of the earliest expressions of the emerging Chicano arts movement. Carlos and Magú were perfect foils for one other: where Carlos was worldly, traveled, experienced, bookish, cosmopolitan, and intent on a career in the art world, Magú was streetwise, a *vato,* immersed in the local scene, passionate about Chicano culture and building an arts movement emanating from the explorations of Chicano identity. Magú immediately recognized Carlos's talent and charisma, and made it his mission to "baptize" Carlos as a Chicano—to get him to trust his experience as a Chicano as a suitable place from which to create art rather than trying to fit into the mainstream art world. Their discussions about art, identity, and politics evolved into a deeply intimate and personal friendship that would embody the Chicano brotherhood, or *carnalismo,* and test its parameters.

Carlos's outlook changed dramatically later in 1971 following the death of his younger brother Ricky. Ricky was the family's golden child—athletically gifted, a poet and musician, smart and well-liked. But Ricky also developed drug problem and, at just twenty-two, he died of an overdose in the living room of his parents' home. For Carlos, the tragic irony was inescapable: six months earlier, his younger brother had visited him in the hospital as he himself fought for his life. Now his brother was dead. The experience marked him deeply. As he would later recount, "I decided to become involved with social issues and [to use] the vehicle of the mural as the means by which I could…try to redeem my brother's life and try to reconstruct my reality through my work in murals."[2]

Carlos threw himself into the movement, becoming immersed in the study of Pre-Columbian art, history, and mythology. He also studied Mexican history (particularly the Mexican Revolution), read Octavio Paz, and became engrossed by the lives and works of Diego Rivera, David Alfaro Siqueiros, and Jose Clemente Orozco—the Mexican muralists known as Los Tres Grandes. Carlos would embrace the artist's role in the movement as a cultural worker, teaching art to children at Plaza de la Raza Cultural Center, working with gang youth at the All Nations Neighborhood Center, and producing political propaganda for the United Farm Workers (UFW) boycotts.

Carlos's involvement with the Chicano movement was inspired by a deep sense of idealism, embodied in the figure of Cesar Chavez, the leader of the UFW. One July afternoon in 1973, Carlos made the five-hour trip north to UFW headquarters, outside Bakersfield. When he arrived he met Luis Valdez, an artist and activist who had

formed El Teatro Campesino, a performance troupe that used agitprop theater to organize Chicano and Mexicano farmworkers for the union. Valdez promptly introduced Carlos to Chavez, and Chavez quickly enlisted Carlos' support of *la causa*. In turn, Carlos embraced Chavez and Valdez, who became two of his most beloved role models. Valdez impressed Carlos with his knowledge of Pre-Columbian mythology and his ability to create a theatrical art form based on its aesthetic principles. And in Chavez, Carlos found a father figure and a role model who equated political struggle with a deep spiritual practice.

Carlos's first assignment with the union was to work with Andy Zermeno as an illustrator for the union newspaper, *El Malcriado*. With Zermeno, Carlos learned that his work had to be direct, simple, and to-the-point in order to convey concrete political messages to people who were not always literate. In this medium, communication and politicization were paramount—an art form stripped down to its essentials. This approach to art making found its greatest expression in the banner Carlos painted for the UFW's first constitutional convention in 1973. Working with a $150 budget and using techniques influenced by Mexican muralism, Carlos and Mark Bryan (a fellow Otis alum), with the assistance of Barbara Carrasco and a steady stream of L.A. art comrades, created a dramatic backdrop that would be intelligible to the nonliterate. Both aesthetically and technically, this liberated Carlos to paint in a straightforward, representational fashion, something he had struggled with during his time in New York.

Almaraz painting a United Farm Workers convention banner, 1973

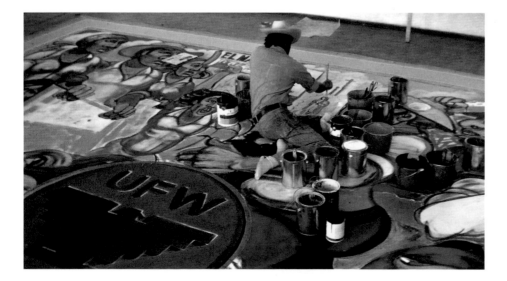

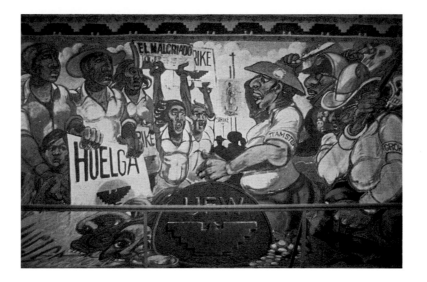

Almaraz's UFW banner on display at the Los Four exhibition, Los Angeles County Museum of Art, 1974

Back in Los Angeles, Carlos continued his movement work while returning to Otis to complete his MFA; during this same period, he also participated in cultural exchange trips to China and Cuba. His friendship with Magú would soon bring together the talents of the group of artists that would come to be known as Los Four: Carlos, Magú, Frank Romero, and Beto de la Rocha. Each was affected by the cultural politics of *chicanismo*, but most importantly, each came to the group with a vastly different viewpoint born of distinct personalities. The challenge and poetry that became Los Four lay in bringing these disparate strands together to formulate a cele-bration of Chicano art and culture. In practice, this meant that the cultivation of their artistic expression was intimately linked to the intricate inner workings of their personal relationships. The process was not always harmonious, but it was fruitful. They spent countless hours trading sketches and engaging in "mental *menudos*"—passionate discussions about art, politics, and *chicanismo*.

In 1974, Los Four became the first Chicano artists to show at a major museum in the U.S. with their exhibition at the Los Angeles County Museum of Art, a tour de force that brought the sociopolitical, cultural, and spiritual practices of Chicano Los Angeles into focus for the first time for an affluent Westside audience. Carlos's works in the show included his first UFW banner and the incendiary statement he made upon his graduation from Otis titled *An Aesthetic Alternative*. He also exhibited paintings of folk characters such as La Llorona, a legendary ghost in Mexican folklore. Magú paid homage to street influences and humorous aspects of Chicano culture, mounting the front end of a heavily lacquered 1957 Chevy lowrider and surrounding it with cartoon-like characters painted on tortillas and *pan de muerto*. Romero's

La Fuerza Del Pueblo, 1977

whimsical paintings of everyday objects such as automobiles and cowboy hats spoke of the influence of popular culture in Chicano culture, while De la Rocha's exquisite pen and ink portraits of his mother and his wife highlighted the role of family in Chicano culture. While the individual offerings spoke to the various elements of Chicano culture, the group's collaborative pieces—a twenty-by-ten-foot spray-painted mural, and a ten-foot-high altar—suggested that the ideals of collectivity, community, and cultural pride, along with the political imperatives of equality and justice, were the substances that held the *menudo* together.

Though it was historically groundbreaking, the celebrity of Los Four was to be short-lived outside Chicano art circles. Eventually, the collaboration grew to include artists Judithe Hernández, John Valadez, and Leo Limón, and with new personalities, the chemistry of the group shifted. Fame proved to be too much for Beto, who quit the group, withdrew to his home, fasted, read the Bible, and destroyed his art. Magú left Los Angeles to help create the Chicano Studies Department at California State University, Fresno. Romero became more involved in his work with the city, and Carlos continued his shift toward leftist politics while completing his MFA at Otis. Close bonds between the original four members remained, but the trajectories of their individual lives diverged as Los Four became a concept for collaboration rather than the expression of its original four members. In 1979, Carlos formally resigned from Los Four and headed downtown to take a studio space on Spring Street, where he would resurrect his dream of becoming a full-fledged studio artist.

By the late 1970s, the once passionate and idealistic objective of an art movement born of a people engaged in defining a new cultural identity had, for Carlos, arrived at a transitional point. Political art collectives became divided and fragmented. Groups and individuals competed for recognition and funding; as funding became increasingly scarce, many artists by necessity took on commercial production—a decision that could be viewed as counterrevolutionary. What was once a united front of Chicano art began to buckle under the weight of controversy and disillusionment.

Additionally, Carlos was repeatedly frustrated by the prevailing attitudes of both critics and scholars who considered Chicano art to be mediocre regional art at best or simply a form of folk art rather than an emerging contemporary genre in its own right. For years, he confronted the marginalization—or "barrioization," as he termed it—of Chicano art by the mainstream art world. What Carlos understood that many did not, however, was that this was precisely the result of the varied strategies Chicano artists and activists took in waging their ubiquitous, yet vague, calls for cultural self-determination. Coupled with the lack of support for the development and acknowledgment of strong individualized styles by artists, the majority of Chicano art became

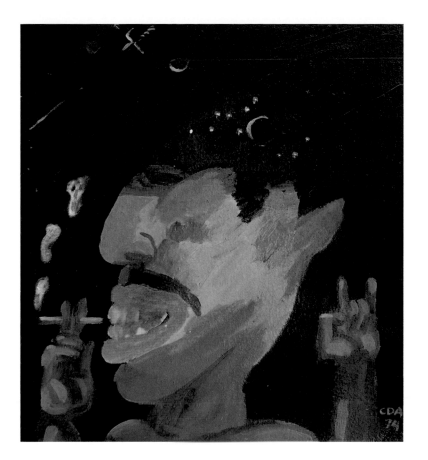

El Pingo Azul, 1974

pigeonholed into common stereotypes. When mounting exhibitions, curators looked specifically for stereotypical Chicano imagery: lowriders, burning hearts, Virgins of Guadalupe, and *cholos* and *pachucos* depicted in hot Latin colors. Chicano artists who developed their own unique styles were often excluded from major exhibitions, and were thereby denied opportunities afforded those who were producing what was expected.

This catch-22 was most evident in the efforts artists made in developing a distinct visual vocabulary for Chicano art and, in turn, how that vocabulary was received by the mainstream art world. More specifically, cultural nationalists advocated for Chicano art as a distinct cultural expression independent of the American cultural matrix. As such, Chicano art could not be interpreted or evaluated along the same lines, with the same language and aesthetic standards as any other avant-garde art movement. Initially this proved to be a unifying strategy among Chicano cultural workers, providing a common cause and rallying point as well as promoting a shared sense of identity rooted in struggle and opposition to the mainstream.

Unifying as it was, *chicanismo* and the lexicon of Chicano art acted as an insular language, one inscrutable to those outside the communities that made up *la chicanada*. Art dealers and critics rarely had the cultural tools and sensitivity to read Chicano art with any sort of depth. Mainstream attempts at penetrating this internal dialogue were often considered suspect. Additionally, those inside the movement wishing to bridge the cultural gap often were also considered suspect, and risked being labeled as sell-outs. Consequently, the movement began to implode even as its momentum grew. What was initially bonding—drawing the lines of strategic essentialism and cultural nationalism—soon became the yoke around the necks of artists who wished to cultivate larger audiences and mainstream recognition.

Carlos found himself caught in the middle of this conundrum, and ultimately opted to remove himself from it—an extremely difficult but necessary transition that served to cleanse and replenish his creative spirit. His move baffled all but a few of his closest comrades. After all, the commitment he demonstrated as a cultural worker and the passion with which he embraced leftist politics and ideology led many to believe that Carlos had indeed found his life's calling through the movement. As Frank Romero would candidly report some twenty year later, "Carlos went from a complete radical handing out [Mao's] Little Red Book to a raging capitalist."[3] Rather than confronting the establishment head-on, Carlos recognized the value of working from the inside, and he did so in a manner that edified his personal goals. Certainly this coincided with his personal aspirations to distinguish himself as a major American artist, for which he was criticized by those who remained more directly aligned with the Chicano movement.[4] But Carlos persisted, thereby forging a path for others whose artistic vision did not fit neatly within the framework of traditional Chicano imagery.

At the time, the Los Angeles art scene was beginning to stir with new energies; downtown L.A., with its cheap rents and abundant industrial loft space, became one of its creative hubs. Carlos's enthusiasm about the possibilities of an expanding art market was infectious; friends and fellow artists, including John Valadez, Guillermo Bejarano, and Victor Durazo, made the move to Spring Street along with him, and master printer Richard Duardo set up shop downtown in the art district around Traction Avenue. A solid cadre was forming. From his studio, Carlos began to elaborate on some of the iconographic images that had continually surfaced in his work. He began to render more passionately his beloved Los Angeles as well as his own complex interior landscape. Freeway overpasses, cityscapes and inner city parks, burning cars, hillsides and palm trees—all capturing the flavor of his hometown—exploded onto the canvas. Addressing urban themes and examining further the idea of a universal

language, he broadened his discussions of life in the barrio to larger audiences. He did so by connecting themes of an urban Chicano experience to the more universal exploration of city life, searching on canvas for the cultural threads that linked people across time and space.

Carlos's first significant attempt at exploring these themes came in 1979 when he debuted his landmark *Car Crash* series as part of the exhibition *L.A. Parks and Wrecks: Reflections on Urban Life* at Otis Art Institute. Though this series became one of Carlos's most effective forums for providing social commentary, its origins were intensely personal. The series was born when he lived in a one-room bungalow overlooking Echo Park. As if from a page from one of his many sketchbooks, his own car had been sideswiped and totaled while parked alongside the park, after whic he traveled mostly by bike or city bus. The incident triggered compulsive thoughts of cars careening violently into each other. The phantasmagoric images were rein-forced by the numerous highway accidents he had witnessed in his years traveling back and forth between Los Angeles and UFW headquarters in California's Central Valley. Carlos's psychiatrist identified the scenes as symptomatic of a deep, unexamined anxiety. Once again facing his inner demons through his work, Carlos painted the images obsessively, generating in the process a body of work that became a foundation for his new artistic direction.

Another Crash, 1979

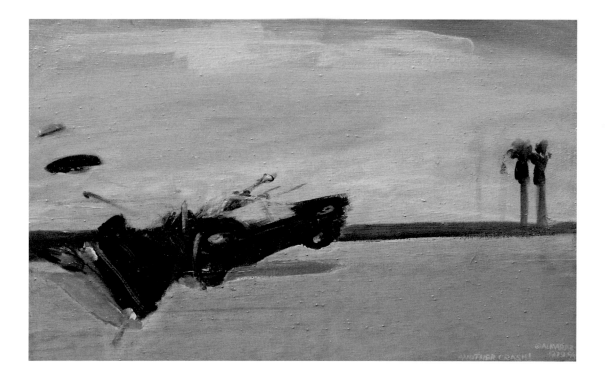

What began as preventative therapy soon became a provocative forum for social commentary. On its broadest level, the series bound together the four elements—water, air, earth, and fire—and infused them with an almost supernatural energy invoking the power of creation. And yet the images were those of death and destruction, thereby unifying the very continuum of existence. Carlos likened the carnage of crashing cars to a modern day sacrifice similar to the Mesoamerican rituals he studied during his period of cultural reclamation, in which innocents were offered up and through their individual deaths, collective life was renewed. On another level, the series itself became a polyvalent metaphor of contemporary reality, a burning effigy to the technological age. Carlos espoused the works as a representation of a clash of twentieth-century man and machine, a clash of cultures—in other words, commentary on the human condition within the context of one of modernity's most powerful myths: the American Dream as represented by the automobile.

As he had intended, the themes invoked by the crashes were universal, yet in this manifestation they portrayed every person's worst nightmare. It was through the use of color, movement, and all the earthly elements fused together so seamlessly, however, that viewers were entranced and summoned deep into their sensory bodies. Here, Carlos wove some of his most lyrical magic; as if having been cast upon by a spell, viewers would stop, stare, study and sometimes buy these seemingly horrific images to take home. This was the stuff of dreams: haunting, surreal, hyperreal, or nightmarish, perhaps, but an incisive interpretation of the American Dream just the same. With this series, Carlos mined deep into a curious and dark area of our collective unconscious.

During this same period Carlos returned to a medium he had worked with while producing abstractions in New York: pastel chalk. His pastels averaged twenty to thirty layers of chalk per sheet of paper, using a spray fixative between each layer to build a richly vibrant image. He drew with his entire body, as if performing a dance, with fine, sensuous lines in rhythmic patterns and with bold swatches of color. His compositions were dreamlike, dense with content and interpretation: nudes, devils and angels, cars and volcanoes. All that he had learned as a young artist in New York in the 1960s, particularly the countless hours spent at the Metropolitan Museum of Art studying the pastels of Degas and Matisse, was now apparent in his expertise as a colorist and his innovative compositions.

It is important to note that although his new work seemed to have come full circle, it was his involvement in the movement that freed him up psychologically and artistically to find his distinctive voice. As he recalled, it was his work teaching art to youth at Plaza de la Raza that loosened him up to experiment with color and form:

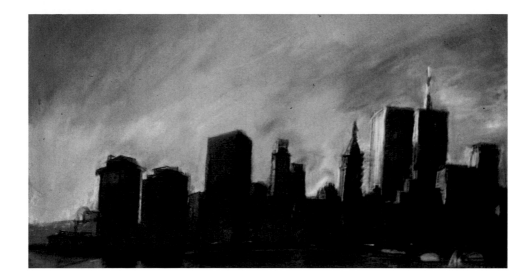

New York City Skyline, 1981

"When you work with children, you work to help them find some expression in art making. You don't really end up with a product. And then I really started thinking more and more about art without a product, art that was more of a process, more something that you had to do, [something] existential rather than something you had to sell and show and carry about."[5]

This artistic transformation also manifested in his personal life. After decades of unfulfilled bisexual relationships, he was rapidly approaching age forty and longed for a committed relationship and to have a child. After decades of therapy working through the web of a confused sexuality and exorcizing the demons that plagued him throughout his lifetime, he dreamed of one day establishing a strong, lasting monogamous relationship with a woman. One of his greatest fears was that he would someday wind up as a lonely, elderly man in a cheap hotel room, as depicted in his work in the recurring character of the Wanderer, a dark, solitary man in overcoat and hat, holding an umbrella or suitcase (as, for example, in *Night Theater*).

Beyond the desire to be part of a couple and family, however, marriage held an additional appeal for Carlos in that it accessed a powerful and socially condoned version of masculinity that offered resolution to so many of the questions that surrounded his identity. As a Chicano, machismo had been clearly modeled for him, but its repressive manifestations held little appeal. In essence, movement dialectics offered masculine identities mirroring the archetypal feminine virgin-whore dichotomy— namely, the valorization of the hyper-masculine (the revolutionary) and the saintly (Cesar Chavez). Carlos wrote often about the confusion, insecurity and vulnerability he felt in struggling to define his own sense of manhood.

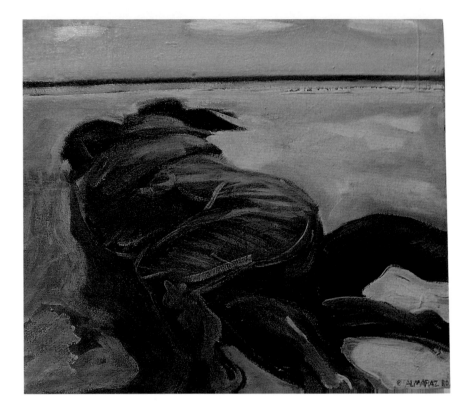

Destiny Piece, Tropical Lovers, 1980

Carlos and I first met in 1974 as fellow cultural workers in the barrio, when he was thirty-three and I was nineteen. A few years later we worked together at Plaza de La Raza Cultural Center where he taught inner-city school children the history of Mexico through art, and myself, through music alongside musicians Louie Pérez and David Hidalgo of Los Lobos and Cesar Torres. With daily contact our friendship deepened and during that time I moved into a studio loft above his own studio space on Spring Street, as did several other artists at that time, after he had convinced me that the emerging downtown art scene was historically significant. I, too, was ready to return to my own painting. After being friends for seven years we began dating as I continued to be impressed by his forthcoming nature and quickly came to trust his honesty, integrity, and his sophisticated knowledge of the art world.

But it was not until I entered his new studio for the first time that I discovered his genius. Missing were images of the clenched fists of the oppressed masses of his earlier political work. In their place, I witnessed a more personalized revelation of the artist's soul. The handling of the material was virtuosic, and I now saw what was never allowed to shine in his work as a movement artist. I gained a new respect for his artistic vision and was compelled to purchase a painting on the spot—a scene

of a dark-skinned man making love on a tropical beach to a voluptuous lighter-skinned woman. He was both surprised and thrilled that I made the purchase, as he needed to pay his rent—seventy-five dollars in three payments! After that our courtship was seamless, as if destined.

On December 8, 1980, John Lennon was shot and killed in New York City, and Carlos was struck by the haunting reminders of life's lessons hard-earned during his own near death experience in the hospital ten years earlier. Deeply affected, he felt a profound urgency not to waste any more time—life was too precious, time fleeting. That very day he moved in to my hilltop Craftsman rental in Highland Park, a barrio northeast of downtown L.A., and together we cultivated the nurturing love he had been seeking for so many years. As Carlos became even more comfortable in his new domestic role he was able to let his guard down trusting that I wasn't going to judge him or abandon him. I was happy that he felt safe enough to expose his demons so candidly. I loved him for that. I loved that he was in touch with his feminine side, his deep sense of self-reflection and sensitivity. It was refreshing to encounter a Chicano who was so different from all the others I had met after having spent most of my life pushing back against the prevailing macho "boys' club" mentality that more often than not objectified woman, disdained feminism, and ultimately kept me from wanting to work with any Chicano arts collectives. Eventually I chose to retreat to my own studio to work solo as an American artist who happens to be a Chicana; but in the process, I found something much more precious—I found true love and equality in a unique partnership. In 1981, we eloped to Mexico's tropical Yucatán paradise, and a year later we returned to the Yucatán to conceive a baby. Maya Linda Almaraz was born on March 9, 1983. His dream was complete.

By 1982 Carlos's career was booming with a run of successful exhibitions in Los Angeles at the Janus Gallery, the ARCO Center for Visual Arts, and the Municipal Art Gallery, as well as other respected contemporary art galleries and museums throughout the United States and internationally. One of his most significant personal accomplishments, however, was having the opportunity to make his comeback in New York. Toward this end, he set about wooing one of the galleries he most respected ever since his early years in New York City, the Allen Stone Gallery. Carlos made several pilgrimages to New York before Allen Stone included his *Car Crash* paintings in an exhibition titled *New Talent*. In Stone, Carlos found a mentor the likes of which he had not encountered since his early days working with Cesar Chavez. Rather than a spiritual mentor like Chavez, however, Stone guided Carlos in his art. It was with Stone's tutelage that Carlos took his work to the next level. Stone critiqued his painting, suggesting better articulation; from then on Carlos concentrated equally

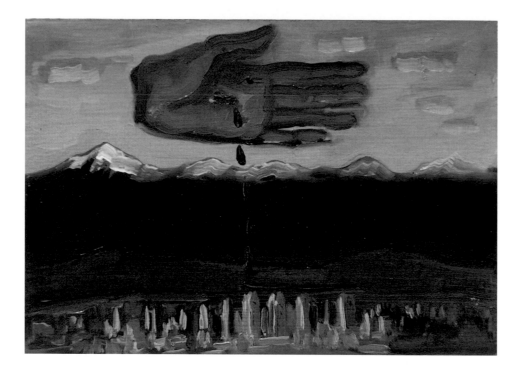

Stigmata Over the City, 1989

on the surface texture of the paintings as well as his imagery. One of Carlos's most significant works, *West Coast Crash*, was a direct result of this collaboration. Stone was pleased enough to exhibit the piece. As an unknown talent in the New York art scene, Carlos's offering went unsold. Ironically, *West Coast Crash* was later exhibited posthumously at the Museum of Modern Art in 1993.

Having generated both financial and domestic stability, he had little need or time for the highly social, political activist circles he had left behind. His family, his home, his studio, and a close circle of friends made for a full and satisfying life. Resentments brewed during this transitional period, as Carlos was seen less and less in Chicano circles. There was a growing animosity among the peers he had left behind, who criticized him for supposedly selling out. Most criticism spoke to how dearly he was missed, and of the deep void in the Chicano arts community left in his wake.

Carlos understood this, but he knew the new direction he was taking was an authentic expression of the artist he was becoming and, more importantly, the artist he had long envisioned. He had few regrets, and spiritedly engaged his political comrades in endless hours of theoretical sparring. He wanted to teach his friends what he had learned and wanted to bring them along with him. Some resisted, but some who paid attention followed his example and found further success in establishing their own careers in the contemporary art circuit. Those close to him were aware that

there were no accidents to his success, and that he had actively engineered the new vision he had created for himself. While the broader art world celebrated its ever-newest "discovery," in truth, Carlos had worked a lifetime to get to this point.

Tragically, the renaissance he experienced was short-lived. Carlos was diagnosed with AIDS in 1987; deeply shaken, he once again stood at a threshold. It would be his final call to adventure. It necessitated moving through what Joseph Campbell described as the "active door, the archetypal image that communicates the sense of going past judgment, going past the realm of the dualistic rational world view...beyond the pairs f opposites, beyond good and evil, into the unconscious, the space between thoughts. And in this place one encounters many trials in which they untie the knots of repression, and the deeper one goes into the self towards realization, the more dangerous the tests become."[6]

Entering into the final stage of his journey, the outcome of Carlos's entire life would depend on how he handled this final test. Embracing his call to adventure, Carlos set out towards self-healing and self-realization. His final work became a documentation of that journey. Moving beyond the threshold, his explorations of the collective unconscious became the catalyst for his healing. In viewing this work his audience partook of that experience and learned from it. By tapping into the same realms of consciousness, they affected their own personal healing. Through his own seeking, Carlos himself became a healer by the time of his death on December 11, 1989. After finding domestic bliss he would often comment on what a relief it was to be at peace with himself. I am glad he knew that peace at the end of his lifetime.

This essay is excerpted and adapted from a forthcoming biography of Carlos Almaraz by Elsa Flores Almaraz and Jeffrey J. Rangel.

1. Dan Guerrero, interviewed by Jeffrey J. Rangel and Elsa Flores Almaraz, 2006.

2. Carlos Almaraz, oral history interview by Margarita Nieto, Archives of American Art Southern California Research Center, Los Angeles, February 6, 13, 20 and July 31, 1986, and January 29, 1987 (www.aaa.si.edu/collections/interviews/oral-history-interview-carlos-almaraz-5409).

3. Frank Romero, interviewed by Jeffrey J. Rangel and Elsa Flores Almaraz, June 2, 2003.

4. Though they did not name Carlos specifically, Malaquías Montoya and Lezlie Salkowitz-Montoya, for example, were highly critical of Chicano artists' efforts toward creating wider audience bases. See "A Critical Perspective on the State of Chicano Art," *Metamórfosis: Northwest Chicano Magazine of Literature Art and Culture 3*, no. 1 (Spring/Summer 1980): 3–7.

5. Carlos Almaraz, oral history, Archives of American Art.

6. Joseph Campbell, *Pathways to Bliss: Mythology and Personal Transformation* (Novato, CA: New World Library, 2004), 114–16.

A Life Transfigured in Words

Selections from the Journals of Carlos Almaraz

Compiled by Elsa Flores Almaraz

Perhaps more than any other quality, Carlos Almaraz's life was characterized by *transformation*. Carlos possessed an intense intellectual hunger and a seemingly fearless call for cleansing and rebirth—qualities that would, at times, prove terrifying and psychologically disturbing, but would also serve to cultivate a sublimely fertile landscape for his visual vocabulary.

Carlos was a prolific visual artist. Less known, however, is how prolific he was as a writer and poet. The fragile but tenacious resilience of his human spirit is openly revealed in the many journals and sketchbooks he produced, which demonstrate the brutal honesty with which he engaged the creative process. I have always been deeply moved by the authenticity, vulnerability, and courage he displayed in sharing so candidly his journey of self-realization.

Passages from the journals paint an intimate portrait of a young, struggling New York artist, conflicted by questions of sexuality and art while seeking spiritual and intellectual knowledge. His later pursuits of an authentic cultural identity as well as his personal truth and happiness were part of a life-long quest to decipher what it means to be a man.

Carlos writes poignantly about surviving sexual abuse, mental illness, and alcoholism, the latter of which brought him close to death in 1971, nearly twenty years prior to his actual death. The passages selected here, ranging in time from 1966 to 1980, help decode those mysterious qualities that imbue his work beyond the easily observed whimsy, indicative of an underlying, energetic potency that is unseen yet profoundly felt. As he consciously grappled with personal demons, Carlos entered the realm of mythos and archetypes in the development of his own personal iconography.

Although his demons would resurface toward the end of his battle with AIDS, it is interesting to note that once Carlos found domestic harmony and personal fulfillment during the final decade of life, he no longer journaled in the traditional sense. Nevertheless, Carlos left a rich catalogue that documented his internal life as boldly as the canvases that revealed his creative vision. The final transformation of his life—to a family man with stable, loving relationships and a strong personal identity as an artist—was complete, a transfigurative resolution to a life beset by profound personal challenges so intimately described in the works he left behind.

March 7, 1966

This is not meant to be a diary, but it is to be a collection of thoughts which are often incoherent: I open the door, enter the room and see a multitude of objects which do not register because it is a familiar order. Yet if part of this order is not, then I become aware.

March 19, 1966

I am so far from realizing the fear of Rimbaud yet can only feel it though my stomach as if I, too, had tasted his poison. Somehow the pain attacks me. How can I release my mind; and why is my life in such a pretentious orderliness; I am bound to nothing and yet remain encroached by my own aim.

I am guilty; guilty of using art as a pretense; never relenting myself completely to it. It is a weapon, an excuse for my own confusion. I am not truly interested in what it speaks but only want to glorify my banal existence through it. I stand in judgment of a spurious toil.

I am bewildered by life, attracted madly to its passions yet remain aloof to its demanding consequences.

May 1966

Music is hollow, it no longer speaks to me of the tree nor the water's wave. Optimism still coats the divine soul, still shields it from anguish but all too persistent. The demand is too great, I shall not bear but can only be. I want no void but instead to fill all with the emotion that the moon scatters so briefly, there is no anguish which I have not created, no hurt which I have not made myself.

June 1966

I am a fool, a fool to want to believe you, to want to wrestle with the devil to prove that he does not exist, to want the small boy to keep his vision, vision of the world unmarred by man's compulsion.

June 25, 1966

I have just finished cleaning out and throwing away all those little scraps of old drawings and minute ugly little abortions which I have foolishly stored up for over a year. How frustrating it is to look back and see your own ignorance; your own struggle manifested in a desperate attempt toward form…. What a banal existence my mind must have been in; what naiveté!

For so many years it seems that I have been in stages of regret for one thing or another. When will it stop; when shall I feel that what I have learned and how I have been conditioned was not all abortive, was not all my precious little brain wasting away time and learning nothing? The perfection of art can only be achieved through a clear insight and though an awareness of a goal; if not in particular, at least a general direction. Have I even come close to such a direction?

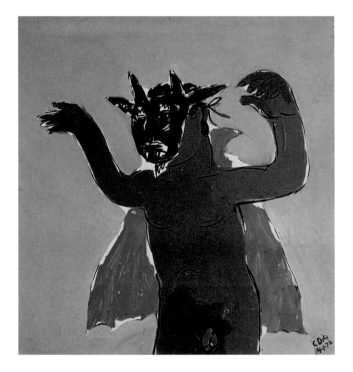

Untitled (Naked Man in Mask), 1972

August 7, 1966

There is no escape through others. The despair and dissolution is filled and can only be filled with new self-appraisal. Any experience can only be called an achievement if after the turmoil there is self-awakening: a self-knowledge that was not there before. Knowledge remains only in the logic found throughout and abstract formulation of ideas; ideas that have been stirred by the emotional impact of reality. Yet reality remains unknown, only hinted by the slight contact we may have in art. Then one needs the purity of art to cleanse the body, the soul, the spirit: There is no self-lament: all remains clear vision: all remains inspirational.

How can the soul or spirit or mind cleanse itself so that it can see anew? Religion offers only a regression into faith. But faith is not part of what I consider immediate. It, too, is abstract but unreal as the vision of a star and inaccessible as color. It is a blurred outline of my own reality. To sense reality on my own being, to sense a truth on what I desire truth to be seems so much closer to what I am now and strive for.... How I wish to forget all reason and to wail in my own mire. Yet I can't. I demand the equation....

I lack any sense of morality, whether it be my own or that morality imposed on me by heritage. My heritage is vague but its vagueness, I'm sure, is universal. One must discipline the mind to function with the body; wholeheartedly, without restraint. All altercations must be salvaged and used as a testing ground for one's own power.

October 24, 1966

Have just finished reading some material on Picasso and have been extremely moved, not only by the scope of his mind and the playfulness of his imagination but more so by the love and devotion which he renders to the optimism of mankind; such a contrast to exist in this century when all positions seem so nihilistic and when joy and man's hope find few people concerned. He is warm and wanders among winter foliage with laurels intertwined in lockets of brilliance and eternal enchantment....

Attending a poetry reading given by Allen Ginsberg makes me realize that I cannot escape the prevailing political situation and yet I wish it to be someone else's responsibility for I find myself with little knowledge concerning things of war and social afflictions. He too displays the optimism which few, nowadays, share. His voice is soft, he remains extremely well controlled, candid and intimate.... His beard was not so full but gave [an] impression that reminds me of Whitman. I'm sure he is well aware of it. Ginsberg's body is soft, and his head with all its black hair slightly overpowers his fragile body. He is very loving.

October 30, 1966

Had a most profitable weekend. On Saturday Mell Alfier and his wife bought one large collage, "Collage with polaroid neg" for $150 and small collage "Morning Dance" for $50...hated to see the large collage go because it was one of my favorites but I'm too young to have favorites to be precious about the too little work I have now....

Visited the Philadelphia Museum of Art. What a collection of superb modern painters. A most complete selection of Marcel Duchamp.... They also have some of the most exquisite examples of Klee at his best. It was sheer joy and love that I experienced when seeing his delicate and profound wisdom.... I have never been so close to him.... His genius bewilders me. There were at least twelve Cézannes, including his large, if not largest, painting of bathers composed around a triangle. His blues were ever so limpid and his forms were precisely distorted.... Many of the painting had been loaned...[so] I missed seeing the Lautrecs again....

In New York I am able to attend some classes at the Art Students League, which again connect me to the old school of New York, the pre-Abstract Expressionist school, the Ashcan School of New York.

December 2, 1966

There are no aspects of the prodigy in me: if art is to become my life then it all must come out of a sense of sober craftsmanship…. There is really little that enters in this self-conviction that is or should be emotional, all remains menial but by no means, although sometimes granted, an inexorable drudgery. If nothing else I would like to achieve a sense of poetry on a visual level and not having to resort to literature for material. Vision alone should provide order by which the eye can sense the somber rhythmic phrase. Gertrude Stein provides a new poetry that derives its order or beauty from the very structure of the language…. The musical order in Stein is really dominant in the visual arts. The purist of abstract art lacks the soul by which we can compare most musical pieces…. By *soul* I am speaking very personally of abstract art as not concerning itself, not that it would have, with musical order. I am not supporting that we take one form and transform it into another…. From reading an essay on *Muriel* by [Alain] Resnais I was able to more vividly see how the cinematic artist is trying to achieve a universal visionary language comparable to the universality of music. What modern abstract painting lacks is cohesion to one central idea. It all becomes very boring after a short time—at least Pop Art can be extremely offensive. The only abstract artist that still disturbs me is Pollock.

November 22, 1967

I think perhaps that I am really a Carlos. I don't look like a Charles but feel less like a Carlos; I have to remember, however, that my mother named me Carlos.

February 1968

Personally, I don't think I've learned the art of wearing masks. I have been so preoccupied with being one honest whole that I have not looked to see if it would be more reasonable to be a collection of individual and often contradictory parts.

March 27, 1969

I was admitted into Mt. Sinai today and although I don't feel as bad now as I did when I applied I'm glad I've gone through with it.

Was given a two hour interview; it was quite thorough. They gave me a robe and a clean pair of slippers.

December 17, 1971

He who does not fulfill the smallest moment can never fulfill the larger cycle.

"An Aesthetic Alternative," 1972

I'm losing my interest in art and I can't sympathize much with purely formalist art nor with artists who maintain this structure. However, I've already invested a third of my life on art; I can't turn back now…. I propose an art that is not property; an art that will make other artists aware of their real duty as human beings. I propose an art that will not only be an inspiration or an education, but one that will destroy the present system of aesthetics. I want to make art and life one again.

Untitled (Grid Series), 1972

February, 8, 1972

My lack of interest for women's sexual demands seems at first to just be ignorance and fear. I know where the ignorance came from but not too sure where the fear came from. My interest in men as a father search but wanting physical attention becomes terribly unreal. Let's just say that I was a little boy looking for a father, and upon finding him couldn't let go....

My interest in women is also due to my intensely disgusting experience with most men. I wonder what my life would have been like if I had grown with both interests consciously in mind. Confusing, no doubt, but probably very interesting. And to be more objective, amusing. I sound as if I'm playing with the devil again. I have been sensitive to only one need; now I have the pleasure to delight in satisfying the second and more realistic side.

November 21, 1972

I feel very discouraged. Attended a Mechicano [Art Center] meeting last night. We're trying to raise money for announcements and such and plan to do it by washing cars. We're talking about pennies. Is working with Mechicano going to be a series of car washes?... Perhaps I'm a little too ambitious. Perhaps not. I'm not very patient. I get discouraged all too easily. I don't like that. Perhaps it's a little childish. Is there any change I can really effect?

Sketchbook #61, TRAVELIN, B'AINT DRINKIN, 1972

Gilbert (Luján) and I talked about being a man or a macho, as he put it. Once again, I keep thinking that I have to be the macho he wants to be. He is pretty macho. Convincing. I believe he thinks that everything else is somewhat queer.

I am different, I don't think that I could change much of it. I don't really want to, but I do want to change. Where does this change start? In me. Yes, I know. Who will tell me what this change looks like? I will, I know it's coming or will I just go through life in this pathetic manner. It's really not going through life, instead, staying in the middle of a very stagnant pond.

Page from sketchbook, 1972

Am I supposed to be more like a Chicano or more like me. Well which is really me? Something more like both. Wouldn't you say? Roberto de la Rocha said that I look like a Mexican Indian and speak like someone from another planet. What exactly does that mean? Pedantic? Probably. Naive? Very much. Dumb? Over-read? Whatever it is I don't think I can change. I'm too old already.... I wish I were Gilbert. I really do. He seems so much happier than I.

LEFT: General Hospital sketchbook no. 2, 1971
RIGHT: *At Gilbert's*, 1973

The handwritten note (right image) reads:

At Gilbert's

Today, at Gilbert's, I was thinking how my life will be not being married. Without feeling sorry sorry for myself and trying to face facts, I admit, it will be a lonely life. I suppose I'll get a lot of reading done; some how that sounds depressing. (I don't want to feel sorry for my-self or sounds depressing)
There are a lot of nice things here to share. It was a fine day and it looks as if it will be a pleasant evening. I would like to share this with some young lady but can't help thinking that it's a little late for me. I am set in my ways.
"It would be better if you took that outside."
I moved it without making a big deal out of it.

May 22, 1973

Interview with a doctor I have never known.

What was the reason or reasons for your nervous disorder? Tell me about it. I always considered my own disorder as sort of a luxury. It came during a time when nothing was happening, in a sense. Yet there was too much going on. This sounds contradictory, I know. But it seems that during those times when so much is going on we have to ask what it's all for. Is it worth it? In '69 I was confronted with what I thought were several important issues: my own private life, which was in a mess; my brother's life, which was also in a mess and had just been dumped on me. My work which had been tedious and totally unfulfilling. I was drinking a lot in order not to think too much about all this. In the long run this only added to the confusion. You can only imagine what it was like to wake up some mornings and wonder just what in the world had happened in the last two days.... From morning to noon, I had decided my fate in three different ways. From noon to five I had decided that none of the above would work.

By four, everything looked quite helpless. By five I decided I needed a drink to get rid of the blues. I got well pickled between five and eight, and I always arrived at every table quite drunk. I don't recall what used to happen after dinner....

By 1971, just a little after Christmas, I was up to a quart of wine a day, two drinks and a little dope. I did very little after work except get tight.... One night I slipped and consumed almost a gallon of very cheap wine. That did it. I was rushed to the hospital the next morning with an acute case of pancreatitis. For forty-five days I almost died, but I somehow recovered. Apropos, one of the first things I asked for was a sketchbook and a pen. Sometimes I wonder whether I'm playing the role of the artist or actually the artist. I think of that with a certain amount of humor now. At one time I really took it quite seriously. I'm not afraid of telling the truth but I am afraid I'm telling too much. That you'll think of all this as a terrible disorder and wonder how I can live this way. Well, I haven't chosen to live

this way, not entirely. Some of the garbage I would like to get rid of, and the rest, that which isn't garbage, I shall have to pay for in a sense. You have to pay for taking a chance, for finding out something new, and for finding out the little truths yourself. You have a vague feeling that this is going to prepare you for the big ones. Hopefully no one will ask you those. But if they do, you hope you're ready.

August 4, 1973

I received a check today for $30.40. It was signed by Cesar Chavez himself—something I am very proud of. I regret having to ask for my bus fare money from the UFW but there's no other way for me to get up there and I haven't much money to do it myself.

September 15, 1973

I saw Cesar again on the twelfth. It was the night of a full moon (first time I met him it was also a full moon). He has a small and extremely modest office. He slipped out as I was walking in and left me there for awhile to browse through his books. He probably has all the important books on Gandhi's life. The other books varied from Jack London to Chicano publications.... He had 2 very delicately drawn portraits of Gandhi on top of one book shelf.... There was also a large photo of Martin Luther King and one of Bob Kennedy. There was nothing there by Marx or Lenin.... The room was cheerful and reminded me of Cesar very much. There was something comical about his tiny desk; it looked almost like a child's desk; it made the black telephone appears monstrous. I looked at it for some time with a certain feeling of affection. If anything personifies Cesar, it is this desk: small, worn, but extremely neat.

After a long time, he returned and we proceeded to discuss the mural. I was surprised that he responded so favorable so quickly. He wanted me to add one figure to represent police brutality....

We (Mark Bryan and self) have started on the mural and six smaller banners. The work looks good.... I told Mark that centuries ago I would have been painting for the French court, today I'm painting for the Union.

November 16, 1973, Letter to Cesar Chavez

Querido Hermano,

Thank you for your incredibly fast response to my invitation, I'm enclosing a few things on the show that we will be having Feb. 29, 1974.

The show itself is made up of the work that we (Los Four) do. It is an urban image and very unlike the work done for the UFW. The large piece measures 10 × 32 feet. The image resembles the kind of spray-can writing seen all over the city, something that Chicanos are constantly put down for. My argument is that this type of communication is more relevant than selling art at incredible prices to only the rich....

Que Viva La Causa! Que Viva La Huelga!

Your Hermano, Carlos (Charles) D. Almaraz

Cesar Chavez with Carlos Almaraz as he works
on a UFW convention mural, 1973

April 6, 1974

The Three of Us
Lying Together
Feeling Together
The Three of Us
Did Our Minds
And Hearts Touch?
What Purpose?
What Pleasure?
What Outcome?
I Love Him
And Know That
He In His Own
Mind Cares For
Me In My Mistakes
And In My Weakness
And Nakedness.
Can I Have Him
Without Holding
Him As She Does?
And These Words
Answered Remain
Unanswered.
Why Care?

July 16, 1974

Los Four:

Very Bad. Breaking up, perhaps. Too soon. Luján won't give
in…. He was very angry. I got very nasty. I'm sorry that I did…
Maybe I've lost him. And Los Four. Whatever that was.

May 7, 1976

I have cut off all of my male friends. Patricia [Mesa] says
that I'm going through a hating men period. Why? She's right.
Maybe it's because they seem to reject me on my grounds.
I am in need of attention…and it seems that attention must
come from a man at this time in my life.

Maybe it's no more than idle time.

It seems that becoming a whole man is harder than
I thought. It means making certain decisions that involve
sacrifice and sacrifice is so difficult for someone as
selfish as I.

August 22, 1976

Patricia and I are sleeping in separate rooms. I love her
but I'm afraid it's hopeless…. We slept together wrapped
in each other's arms. We would separate only after we'd
start sweating…. We were never intimate, we couldn't
really open our hearts to one another….

I remember San Juan Bautista. When it's hot and dry.
I remember Luis with warm admiration. My love for him is from
a distance, we spoke a little, but I hope that the affection that
I feel towards him is mutual…I would give anything to take that
beautiful face of his and give it a big kiss.

December 2, 1976

I have returned to the beginning of one of my cycles. I am
living alone in an old storefront in what could be termed
a rather depressing environment, but it represents freedom
and a chance to paint and work again.

December 2, 1976

Lovers holding too Tight often go Down with the Titanic,
Together. In the dark.

1979

I'm back in LA and leaving for NY again to help Marvin
on a discotheque on Broadway. Imagine that! What has
my Marxism degenerated into?

1980

If these are times of revolution
When will we have time
To make love to all those strangers
We encounter along the way
To the people's government?
Sometimes it's lonely
Waiting for a dream
That seems so distant
So hard and self-denying

1980

After two years, I had a very important discussion with Luis
Valdez who asked me, why am I doing this? And I said, well Luis,
I told you I want to do my share and do my part for The Move-
ment. He said to me—and it really changed my life—You're very
talented, and you're really doing too much. You really should
do more of your own work, and in that way you will give people
guidance. And I said, I can't believe you're saying this to me, you
who have done so much for so many people besides your own
work, you're telling me that basically I should drop out and do
my work. He says, Yeah, but you should....

I was going to be invited to a show here in Los Angeles
and it got back to me that the curator, Josine Ianco-Starrels, said
"Oh, we can't invite Carlos because he doesn't paint anymore.
He makes magazines."...With Luis telling me "You should get
back to your work" and Josine saying "He's no longer an artist;
he's a layout artist," it was a gift. Coming from her, and with
Luis behind me, I had to listen. I realized that I have to make
a decision whether I was going to continue working for the
Concilio de Arte Popular and for the magazine *ChismeArte*
or get back to my work.

After doing a three-story-high mural, I really had had it.
I needed to return to the studio to do very personal work that
was more or less the other side, my other aspect, my more
introverted aspect, and to develop ideas that were nonpolitical,
that were totally my ideas.

1980

I am a member of a very, dense urban society.... How do I get
out of the regional labeling? How do I make the paintings more
important, more exquisite than just being Echo Park for the
sake of Echo Park? Now I find one answer is to work more with
the material itself...and, secondly to work the idea of city: What
is city life? What is it now? What was it in Rome? What was
it in Pompeii? What was it in ancient Tenochtitlan? It's all the
same thing: destiny of mankind.

Sept. 27 1977 THIS WILL BE THE LAST ENTRY IN THIS RAGGED OLD BOOK.

I'M PRESENTLY WORKING ON THE LAST ISSUE OF CHISMEARTE. GUILLERMO BEJARA AND I HAVE MANAGED THROUGH ONE VERY DIFFICULT YEAR AND SINCE WE HAVE BEEN REFUNDED FACE ANOTHER YEAR OF THE SAME.

YESTERDAY I MEET WITH MARTIN CANO, RENE RODRIGUEZ, AND MEMBERS OF TEATRO URBANO IN ORDER TO PLAN ANOTHER COMIC BOOK.

LOS FOUR IS ABOUT TO FINISH THEIR FIRST AND PERHAPS ONLY COMIC BOOK. I FOUND WORKING WITH LOS FOUR + FRIENDS A BIT STRENUOUS: PROGRES-SION AND COMIC BOOK A BIT MEDIOCRE THE GROUP A LITTLE TOO 'ARTISTIC'. PER-HAPS THIS SECOND COMIC BOOK WILL BE A LITTLE MORE COLLECTIVE.

WORKING WITH LEO LIMON HAS BEE VERY ENJOYING. HE'S A GOOD MAN AN LOVES TO DRAW. I HOPE TO TEAM HIM UP WITH SERGIO HERNANDEZ AT SOME POIN.

MARTIN CANO SEEMS VERY HARD TO WORK WITH. HE DOESN'T HAVE A STRONG EGO AN CAN'T DEAL WITH CRITICISM TOO WELL. I LIKE THE GUY BUT HE'S SORT OF A BLACK SHEEP. I TELL HIM THAT HE SHOULD STAY ZEN.

I'VE BEEN PAINTING SMALL THINGS BUT NOT ANYTHING WORTH MENTIONING. THIS STUDIO IS VERY SMALL AND STRETCH A CANVAS SEE PROVES IMPOSSIBLE.

THE CONCILIO DE ARTE POPULAR
IS AS YET NOT INCORPORATED AND
WE MUST BE IN ORDER TO APPLY FOR
N.E.A. FUNDS. OUR DEADLINE IS NOV.15.
THE PAPER WORK ON THIS PROJECT ~~AND~~
IS TEDIOUS AND SOMETHING I REALLY
NOTHING TO DO WITH, YET, HERE I
AM.

I MET THIS MORNING WITH RAUL
NORIEGA AND MARCELO EPSTEIN.
THEY PRESENTED A 10 MINUTE
TREATMENT FOR A FILM ENTITLED,
"LA VIRGEN DE GUADALUPE, U.S.A."
THE TREATMENT IS BOTH STRONG
AND SYMPATHETIC TO THE CHICANO.
THEY WANT ME TO DO A STORY BOARD

I AM "INVOLVED" WITH A BEAUTIFUL
YOUNG (22) WOMEN NAMED CONCEPCION
VELAQUEZ. SHE WAS GOING WITH RAUL
RUIZ FOR SOMETIME. WE MET IN CUBA.
SHE'S A VERY STRONG WOMEN. VERY MILITANT.
SHE CRITICIZES MY LIBERALISM. I EX-
PLAIN TO HER THAT I'M FROM THE FIFTIES
A TIME WHEN LIBERALISM WAS WAY OUT. I'M
A PRODUCT OF MACARTHYISM.

MY OTHER FRIEND NANCY IS AWAY IN
EUROPE. SHE WROTE AND TOLD US THAT
SHE WAS BOMBED IN A OUTDOOR CAFE
IN SPAIN. SHE IS WAS NOT HURT AND
MOVED ON TO ANOTHER COUNTRY.

I DON'T KNOW WHAT I'LL DO WHEN
SHE RETURNS.

SINCE THIS IS THE LAST ENTRY, I'LL
SAY THAT I'M MUCH MORE TOGETHER
NOW THAN I'LL EVER BE — NOT ALL
TOGETHER HAPPY BUT CERTAINLY NOT
UNHAPPY... FIN.

123

Other Voices

Reflections on Almaraz's Legacy

Compiled and edited by Marielos Kluck

> "At some point in our lives, each of us realizes how really finite we are. For me this realization has been a driving force in my creativity and in my life in general. I paint with a new abandonment almost trying to deny the fact that I too will someday pass on and the only thing remaining will be the images that I leave behind."
>
> —Carlos Almaraz[1]

When Carlos Almaraz made this observation in 1983, it was without the knowledge of the illness that would tragically cut his life short some six years later. While he was correct to believe that his legacy would endure in the artworks he left behind, his legacy also persists in the countless friendships he left behind as well. The following selection of testimonials from those closest to Almaraz reveal that he had a profound effect on those around him not only as an artist, but also as an activist, mentor, advisor, and inspiration. They remind reminds us that behind the mythical art that Almaraz left behind, lived a man—a man, questioning his very nature, as many of us often do.

In assembling this chorus of voices, we received an abundance of tributes to Almaraz. This outpouring of affection and esteem, from nearly thirty contributors, far outran the space constraints of a printed catalogue; we edited some statements for length, while in other cases we were (regrettably) unable to include them at all. We encourage readers to visit lacma.org/almaraz-other-voices to read the full collection, including contributions from Guillermo Bejarano, Daniel Brice, Peter Clothier, Richard Duardo, Harry Gamboa Jr., Leo Limón, Gilbert Luján, Richard Reed, Frank Romero, Daniel Saxon, and others.

Page from sketchbook, 1987

1. *Carlos Almaraz: A Survey of Works on Paper, 1967 through 1989* (Los Angeles: Jan Turner Gallery, 1990), 13.

DAN GUERRERO

Guerrero is a producer and performer who first met Almaraz in grade school. His solo show, *¡Gaytino!* (excerpted below), explores Chicano history, his life as a gay man, and his friendship with Almaraz. Performance clips may be viewed online at lacma.org/gaytino.

Our friend Carlos? An artist with a growing international reputation. And after a long, rocky search for what he wants in life, he marries another artist, Elsa. They have a baby, Maya. We spend a lot of time together after so many years. And when we're not, we're on the phone, just like back on McDonnell Avenue.

Phone call. Carlos tells me he's up at Idyllwild near Palm Springs teaching a summer art course. "But I've been sick with a stomach thing and high fevers for two weeks. I don't know what's wrong."

"Carlos. See a doctor."

Phone call. "The doctor wants me to take an AIDS test."

"What? You? [laughing] That's ridiculous, Carlos. You know what? They want everyone to take one these days. I wouldn't worry about it." And I don't.

Phone call. "Danny G.? I have AIDS."

"No. No, Carlos. That's impossible. They made a mistake. The test is wrong. That happens all the time. Or you misunderstood the doctor."

"I have full-blown AIDS."

Time stops. We both know what this means in the '80s. I tell my partner, Richard. It's a long night.

Next morning, I'm in the shower, deep in thought. I can't believe it. I won't. I can't. Water is streaming down my face. I'm so far away. Suddenly, a horrible sound jolts me back. A cry, a howl like a wounded animal comes from me, from a place so deep you don't know it's there.

During one of his hospital stays, Elsa calls and asks Richard, who has been Carlos's assistant for a long while, to bring sketches for a mural Carlos and Elsa have been working on for the new Ronald Reagan Building in downtown L.A. That's called irony.

When we get there, Carlos is sitting up in bed. Lively. Animated. He proudly holds up a skeletal arm to show how much weight he's gained.

Richard and Elsa tape the sketches up on the wall. Carlos jumps in. "The Hollywood Bowl should be smaller, clouds higher, the hills deeper purple. And more helicopters." The creative spirit strong and well.

He tells a story about a friend that visits earlier that day with her five-year old son, Max. As they leave, Max suddenly stops in the doorway and turns. "Goodbye, old friend." We all laugh. "Old" friend. The kid is five.

When Richard and I go to leave, I take my cue from Max. I turn in the doorway, "Goodbye, old friend". Carlos flashes a smile and takes a cue from me. "Goodbye, old friend." He dies that night. And a part of me, too.

Carlos and I never speak of how he may have caught the virus. It doesn't matter. All that matters is that it takes him.

CHEECH MARIN

Marin is an actor, director, writer, comedian, author, musician, and avid Chicano art collector. His collection includes more than twenty works by Almaraz.

Carlos Almaraz is the John Coltrane of contemporary painters. He puts paint on canvas with wild, effortless spontaneity. At the same time he displays a mastery of technique that would, at first, seem to be in direct opposition to his first impulse. How do you totally let go, but maintain control at the same time? This dynamic sets up a tension that allows anything to happen.

His palette ranges from the most delicate of pastels and watercolors to the jagged edged, black-red blood of dogs in a loud, wet fight. His cars crash on fiery freeways and drop huge chunks of burning metal on those below. Acrid smoke, that you can taste, wafts off the canvas. Meanwhile, back at his version of Giverny, lovers sit on the banks of Echo Park Lake, with their arms entwined around each other, impervious to any evil that lurks about them in the jungles of Echo Park. Clowns and giant

rabbits stand in trios silently watching in the wind. A great deal of the time there is wind. It twists and bends palm trees into corkscrews. *El Payaso*, the clown, is usually watching from the wings. Chaos and calm. And always, there is paint. Paint. Paint in big thick icing trails. Canvases slathered with paint. Paint wedged on with a putty knife. Paint swung across a canvas like a slap on the ass. Paint piled up like it was growing out of the canvas. It is no longer paint; it is architecture.

If Carlos was remembered just for being the leading force of the Chicano art movement, or the man who thought that we were unique and had something distinctive to say, and that the Chicano painters could stand on the stage with anyone, that would ensure his place in history. If he was remembered just for being a sign painter for Cesar Chavez in the grape fields of Delano or the backdrop painter for Luis Valdez and Teatro Campesino or the painter of large, edgy political murals in the neighborhood, that would be enough… but he could paint. Almaraz first articulated the philosophy of Chicano art and then moved beyond it almost immediately.

I am of the belief that paintings are alive and are imbued with the creative energy of the artist. His paintings shine with the constant clarity of a beacon. Every time I walk by a painting by Carlos I'm exposed to this creative energy. I'm changed by it. It's simple quantum physics. It is beyond my control.

CRAIG KRULL
Krull worked with Almaraz as the director of Jan Turner Gallery and Turner/Krull Gallery from 1988 to 1993. Since 1994 Krull has represented the estate of Carlos Almaraz at Craig Krull Gallery.

As an art dealer, I have been afforded the rare experience of journeying into the mythical cosmos of two visionary shamans and quintessentially Los Angeles artists, Edmund Teske, originally from Chicago, and Carlos Almaraz, born in Mexico City. These artists did not habitually shut off the lights in the studio at the end of the day; they were always opening the windows and doors

of perception. Teske's poetic darkroom alchemy employed chance techniques that allowed for the Hindu-inspired interplay of natural forces. Almaraz combined childhood memories, visions of a near-death experience, reveries of anthropomorphic animals, and dreams of space travel into fantastical spectacles layered with playful and potent iconography.

Like Chagall, to whom he is sometimes obliquely compared, Almaraz was captivated by theater, and his fanciful ensembles often occupy stages or float about in symphonic swirls. He employed masks and magicians, buffos and lovers, to conjure enchantment. Like Teske, Almaraz assembled and transformed one reality into another. This he often achieved by morphing sequential images in grids so that a jester's triangular hat became a pyramid, then a volcano, and then the sail on a boat that would drift away. Coping with his fatal illness, he drew rockets streaking to the stars. Edmund Teske and Carlos Almaraz orchestrated metaphysical journeys, divinations, and surreal séances, and I am forever grateful for the trip.

MAYA ALMARAZ
Almaraz is an environmental biologist who received her PhD from Brown University in 2016. She reflects on her relationship with her father before and after his death.

My father, Carlos Almaraz, died when I was six years old. I was too young to have gathered a great deal of experiential memory of my time with him, so my relationship with him was and is one with his art. My father lives today as the many pieces of art on my walls, and that is how I know him best. I know him as the optimist who sees a smog-filled Los Angeles sky in a deep, majestic, moonlight purple. I know him as the romantic who turned a seedy barrio park into the backdrop for a lovers' boat ride under the stars. I know him as the scientist who separates biotic from abiotic, evolution from carnage, and energy from fear, as he demonstrates beauty in a freeway car crash. And I know him as the trickster who snuck a champagne bottle into my favorite abstract painting.

My favorite piece of his is one we painted together. This painting represents the inseparable nature of our relationship. The painting is filled with a six-year-old's attempts to recreate an artist's images, and illustrates the quiet but unmistakable influence he has had on me. A near-stranger whose blood is my own has shaped me to my core. The painting is a mix between the two of us. Sadly, this piece was burned in a house fire years ago. All we were able to recover of it was the bottom strip, but this strip is perhaps as important as the whole. Saving what we had seemed oddly appropriate, as it was the foundation of our work together. This painting has since evolved into a different piece of art, with new meaning, and a history that lives beyond its origin. It speaks to how in our brief years together, my father, like parents all over the world, has shaped who I am, yet has not determined who I will become.

SUZANNE MUCHNIC

Muchnic is a former art critic for the *Los Angeles Times*. In 1986 she wrote, "If Carlos Almaraz ever moves away, we will have lost a Los Angeles treasure. I say that because he's one of the few artists here who knows how to paint passion."

I have many vivid memories of the man and his art. Carlos was a gifted painter who brought Los Angeles to life in sizzling landscapes, tense urban scenes, and fantastic images, but his real subject matter was his passion for visual expression. He struggled and thrived amid conflicting desires to be true to his aesthetic heritage and, at the same time, find his rightful place in the mainstream art world. Details of his life may fade, but he is not easily forgotten. Had I become involved in Southern California's contemporary art scene a few years earlier, I probably would have met Carlos in 1974, when the Los Angeles County Museum of Art presented its first major exhibition of Chicano art. *Los Four: Almaraz / De la Rocha / Luján / Romero* was a breakthrough and I missed it, but the importance of the show was still in the air. Carlos's work popped up in local galleries and other showcases in the mid-1970s, but I probably didn't meet him until summer 1979, when Otis Art Institute of Parsons School of Design presented L.A. *Parks and Wrecks: Carlos Almaraz, John Valadez, John Woods.*

That's certainly where I first encountered his paintings of flaming car crashes, and they made a lasting impression. Art history is full of beautiful horrors, but these were different, and exactly of their time and place. They were apocalyptic images for a car-culture town, romantically overheated but all too believable. Carlos envisioned freeway overpasses as launch pads for capsules of fiery death and turned fast cars into flying carcasses. He saw silent nights as stage sets for seething dramas with violent endings.

A strong personality who spoke up about social injustice and celebrated L.A.'s tropical glory, Carlos was on in those days and he was definitely on to something. At his best he struck an uneasy balance in his art, drawing from his education and skill as well as his personal experience and imagination. Proud as he was of his role in the Chicano community, he resented being pigeonholed as a hot-blooded Latino artist and accurately pointed out that Caucasians who used high-key colors were not similarly labeled. Although his art school training and sojourn in New York broadened his frame of reference, he maintained his identity.

JUDITHE HERNÁNDEZ

Hernández first met Almaraz in 1972, two years before she joined Los Four as its only female member. In 1977, she and Almaraz collaborated on the mural *La Mujer* in Boyle Heights, Los Angeles. This story is excerpted from an interview with Marielos Kluck, and has been edited and condensed for clarity.

One of the best stories I have of Carlos is when he was doing the Gallo boycott mural on Soto and Michigan. He was working with the local gang, and these guys were tough, some of them had done things that aren't very nice. [But they] loved him and

they would show up and they would work with him. One day we had to go see our lawyer, a pro bono lawyer for Los Four. I picked Carlos up at the mural and he said "some of the guys are coming with us." So these four or five really tough *vato locos* [crazy dudes] got in the car, and as we got closer to Century City and these beautiful neighborhoods—it was very upscale shopping and business buildings—they were quiet. Before that they had been chatterboxes, talking, laughing, and they had stopped talking. We went into this beautiful lobby, elevators— very intimidating, with the granite floors and gold doors—and we went up to this [upper] floor, and they all went and sat down and they were like little rabbits huddled together suddenly in the lair of the wolf, they had just become children, these bad guys. [Afterward,] they finally said, "what were you talking about? I couldn't understand what you were saying." [Carlos responded:] "That's because you haven't gone to school, it's not a code, it's not another language, it's just English."

Fast-forward forty years into the future. My daughter was going to East L.A. College to finish her general education requirements. One of her professors who taught a political science class she was in was trying to design a program in revolutionary trends. So he invited us to a couple of his meetings, [and at one of the meetings] there was a man who was [the dean] who oversaw the campus. I could see there was some trepidation in his face.

He said, "you know, my colleagues don't know this about me, but I don't want to miss this opportunity to tell you that you and I met before. The last time you saw me I was fourteen, I was one of the guys who went with you and Carlos Almaraz on that trip to Century City to meet your attorney. Knowing Carlos was one of the most important things that ever happened to my life. I got out of the gang, I didn't ever want to be in it but I felt I had no choice. And I finally was able to get away and I went to school, and my life has been different because I knew you guys."

AIMÉE BROWN PRICE

Price, an art historian, has lectured and taught in museums, universities, and art schools and curated exhibitions internationally. She met Almaraz when she was a new instructor and he was a graduate student at Otis Art Institute.

When I first met Charles Almaraz (as he was known then), he had recently returned from New York, where he had delved into what was then the still modish International Abstraction. This was a time (over forty years ago) when personal identities were investigated and cultural differences and specificity increasingly explored and celebrated in art. Among other groups, Mexican-Americans no longer downplayed but turned to the particulars of their individual backgrounds and formulated an imagery to assert it. No one was to do this more vigorously, with greater invention, energy, or protean force than Carlos.

These attributes along with his poetic sense of place were evident in L.A. *Parks and Wrecks: Reflections on Urban Life* (the 1979 exhibition for which I wrote the accompanying text). In his images Echo Park was both a serene, romantic arcadia with just a hint of anonymity and loneliness to its couples boating on glimmering water; and with its palm trees set at regular intervals it was also, nonetheless, a very urban landscape.

He was capturing the dual nature of Los Angeles and was to continue depicting the city with its polar opposites: an Edenic place and one of frenetic contemporary life. With his full-throttle imagination, L.A. became a place of lurking catastrophe, cataclysmic car crashes, and vehicles gone out of control. A black-and-white police car could be read as more confrontational than any two anonymous cars colliding. He presented a full range of moods, from melancholic to underlying menace. Grim scenes are presented with enormous facility and verve of execution; the dire sense of these car crashes is tempered by a kind of comic realism. Like other great artists of the Mexican tradition—Posada, Siquieros, Rivera—Carlos was also committed to making his images accessible to a wide audience and his public works—murals, posters, banners—were, like theirs, potent message-bearers.

I last saw Carlos at his home when he was quite weak and ill, and yet there were remnants of his essential *élan vital*. Much as at a quilting bee, a small gathering of artist friends were seated around the kitchen table chatting, gossiping, and at his direction lovingly collaborating by helping color in and further valorize some of his late etchings (to better support what would soon be his widow and orphaned daughter). Ever thoughtful, he was a physically eroded, hobbled, but reassuring presence. What a superb artist my friend proved to be. He is, and I use this term advisedly, sorely missed. He enriched my understanding of art and yes, life. Yet he endures. We still very much have the heart and soul of Carlos Almaraz in his work.

GINA LOBACO

Lobaco lives in Kauai, Hawaii, and was a friend to Carlos Almaraz and his wife, Elsa Flores Almaraz. She discusses her defense of Almaraz against allegations later in his career that he was a sell-out.

In early 1988, about two years before his death, Carlos was profiled in the *L.A. Weekly* in a story that used anonymous quotes from Carlos's artist "friends" who commented negatively on the changes in his art from the political to the personal. *Vendido* (sellout) was the subtext.

I remember standing in the kitchen with Elsa and Carlos at their log cabin in Pasadena as they looked in disbelief at the tabloid paper spread out on the table before them. Carlos was subdued but if he was angry, he didn't express it forcefully. Rather, he seemed rueful and unsurprised, taking wry guesses at the identities of what today we would call his "frenemies." At the time, he was living with AIDS and only a handful of his closest friends knew about the diagnosis—including those detractors whom Carlos suspected were the source of the anonymous *Weekly* quotes.

The piece also took Carlos to task for his heretical assertion that artists needed to get off the government grant-seeking hamster wheel and take a risk by putting their art out in the marketplace and in galleries. He had become financially successful during the past few years, although he had always outpaced his peers in productivity and creativity. Celebrities, museums, and collectors had recently bought some of his pieces, and he was no longer living on the economic margins. So that made him an object of envy and criticism: He wasn't painting *campesinos* (peasant farmers) toiling in the fields; he was painting Pierrots parading through phantasmagorical landscapes. The implicit criticism was that he had become a lightweight in pursuit of fame and fortune.

Because I knew the then-editor of the *L.A. Weekly* from our mutual political activism, I wrote a letter of complaint about the article. My letter ran a few weeks after the piece, and in gratitude, Carlos gave me a pen-and-ink drawing that reflected his feelings about the whole episode: people with concealed identities. I don't know if he ever brought up the issue with those he suspected of talking to [the reporter]. But as his illness overtook him, he didn't hold grudges and I saw him enjoying the time he had left with them.

JOHN VALADEZ

Valadez, a realist painter and muralist, met the members of Los Four through Gilbert Luján. He later cofounded Centro de Arte Público. The following is an excerpt taken from a written remembrance of Almaraz.

Carlos allowed me to see clearly that I was an individual with instinctive clarity and I should own it, risk taking, singular vision, intuition, *a la brava*, fuck the Devils!

Carlos could talk and, more importantly, listen as if he could hear you and challenge you with questions or demur when necessary. He would piss me off constantly with conversation and he loved it. He had a smile just this side of smug arrogance smothered with respect and humor that belied his intelligence. He was always reading, [about] sexual psychosis, Buddhism, learning French, whatever. He had stories of his travels to Cuba then traveling to China.

We saw a lot of art and films together with [Richard] Duardo, Barbara Carrasco, and anyone else who had a car or gas money. We pulled together all of our resources, art jobs, ideas, and learning skills together. He was the oldest and we all listened and thrived. I always enjoyed watching him work with paint or pastel. I have always felt fortunate to be a close friend of his for about four years, and we all miss him to this day.

BARBARA CARRASCO

Carrasco is an artist and muralist who has created numerous works that have been exhibited throughout the U.S., Europe, and Latin America. She recollects her first experience with Carlos and his lasting effect on her career.

I first met Carlos Almaraz in 1978 when he and John Valadez were painting a mural at the Aquarius Theatre in Hollywood for the play *Zoot Suit* by Luis Valdez. I approached them and shared that I, too, was a muralist and then showed them some of my sketches and drawings. They immediately hired me to work with them. Soon afterward, I joined Public Art Center/Centro de Arte Público. I would commute from Culver City to Highland Park to work with the artists in a shared studio space on Figueroa Street. It soon became apparent to me that Carlos was a very unique individual. He offered suggestions about reading materials related to history, politics, social movements, and classical literature. He believed that such material would help us understand the community work we were doing.

At the time, I was in my early twenties and had recently graduated from UCLA. He was impressed that I had met and worked with the United Farm Workers while I was an undergrad, and he encouraged me to continue creating art for the union. During the early 1980s, I found myself fully engaged in community work, collective art making, participating in public forums, and meeting numerous artists, intellectuals, community members, civil rights leaders, and other individuals who were interested in community art projects. When I decided to pursue

graduate school at California Institute of the Arts, Carlos wrote a letter of recommendation.

There were moments when I felt that I was not being taken as seriously because I was a young Chicana artist. He was very sensitive and did not make assumptions or judgments about my feelings or emotional disposition. His ongoing support of my work was reassuring and gave me the confidence to persevere as a member in the collective. We went to many public events together and enjoyed great conversations that often revealed his brilliant sense of humor. There were also more serious times that gave me insightful observations about Carlos. Once, during the Iran hostage crisis (late 1979 to early 1981), we were on a bus together when someone mistakenly assumed he was Iranian. The man became hostile and threatened Carlos. It was an intense moment, but Carlos was able to calm the man by slowly speaking to him in Spanish while explaining that he was a fellow Mexicano. He also persuaded the man that ethnic and racial hatred was being stirred up by mass media propaganda. It impressed me that he was able to maintain his composure during the unexpected social conflict.

WAYNE ALANIZ HEALY

Healy is a visual artist and cofounder of the muralist art collective East Los Streetscapers. He reflects on his neighborhood connections to Almaraz as a youth in East L.A., and the way their paths eventually crossed as adults.

During those heady days in the early 1970s, when Chicano art was being run through the filters of Marxism, militancy, and machismo, I found myself as a newcomer in a cultural nonprofit called Mechicano Art Center. It was there that I met other young artists who would remain acquaintances, work as collaborators, and/or become close associates throughout the passing years. It was on an autumn day in 1973, while I was hanging my first solo show, that an artist approached me and introduced himself as Charles Almaraz. He was a talkative person who offered to help me hang work, set prices, and formulate sales strategies ("Make up a good story about the piece and they'll buy it"). As we

conversed, coincidental similarities began to emerge. We were both expats, recently returned to our East L.A. barrio after living back East: he in New York, I in Cincinnati. We had attended the same neighborhood public schools. It then turned out that we had grown up only a block apart. However, because Almaraz was four years older than I, we never met. Not even the influence of our most famous neighbor, Lalo Guerrero, the father of Chicano music, had made us cross paths. I had to wait until age twenty-seven to meet the future master.

I learned a lot from Carlos, who liked to throw me zingers. We were about as different from each other as could be and yet maintain a friendship that included a passion for art, occasional performances at *peñas* (folk clubs) where we'd sing farmworkers' *corridos* and take trips up and down Califas. I grew up with art as a pastime competing with my other pastimes. Carlos was one of the first Chicano artists that inspired me to quit my day job and embrace the muse.

LOUIE F. PÉREZ
Pérez is a musician and principal songwriter for the Grammy–award winning rock group Los Lobos. Pérez reminisces on his first chance meeting with Almaraz.
It was beautiful Los Angeles day in the spring of 1977. I found myself walking up the creaking wooden steps leading to an office located in a tired old building that served as the head-quarters of the Concilio de Arte Popular (CAP), the statewide coalition of Chicano artists that published an ambitious little periodical called *ChismeArte*. Back then I was an aspiring artist and I was headed up those steps in the hopes of pitching a few drawings for the magazine. After knocking on the door, I was greeted by a bearded gentleman who looked me up and down before finally inviting me in. "I'm here to see Carlos Almaraz," I told him. He then pointed toward a man hunched over a table that was spilling over with books and art materials. And so began a friendship that was galvanized a few years later when we both worked as resident artists at Plaza de la Raza.

Carlos Almaraz was tremendous. That's how a Mexican woman, in Spanish, once described to me a man she knew that moved in many directions at once. Carlos was a wellspring of energy and creativity. He had the ability to move between mediums of expression seamlessly. As a painter, he could render an image with the skill of a renaissance master as well as paint with the purity and intensity of a child. We would spend many an afternoon sitting in the park that surrounded Plaza de la Raza or in his paint-spattered studio downtown, talking about the books he read, the music he enjoyed, and his philosophy about how to live an artful life that he so eloquently described.

In that office on that afternoon close to forty years ago, Carlos carefully reviewed the half dozen drawings I had stuffed in a manila envelope. "I like this one, I think I have just the place for it." I remember clearly, as I walked down those stairs after our brief meeting, about how he made me feel. It wasn't just the encouragement every fledgling artist needs but he also left me with the sense that we all have value in whatever creative path we choose to follow. That was Carlos Almaraz as an artist, teacher and friend. A man who inspired many that had the opportunity to know him. Gracias, *hermano*.

FRITZ A. FRAUCHIGER
Frauchiger is an art historian who has worked for more than thirty-five years in California and Hawaii. Seeing Almaraz on television led Frauchiger to meet the artist and, eventually, to curate two exhibitions of his work.
Carlos Almaraz was one of the most unique people I ever knew. I became aware of him one night in the mid-1970s while watching a Los Angeles public television show. A bearded man in paint-spattered overalls was being interviewed about his artwork. As I listened, the artist's comments intrigued me. It was Carlos Almaraz being interviewed about an exhibition he had just opened in downtown Los Angeles. I was immediately determined to meet this artist and to find out more about him and his art. At the time I was the director of the ARCO Center for Visual Art, a not-for-profit contemporary art space open to the

public in downtown Los Angeles. After our initial meeting and a visit to his studio I was convinced his work was exactly right for a solo exhibition at our center. The eventual exhibition, called *Urban Myths: Painting* (1982), was a great success by any measure.

In 1986 I was appointed as the new director of the newly forming Contemporary Art Museum in Honolulu. During my tenure there, Carlos and his wife, Elsa Flores Almaraz, bought a second home on the island of Kauai and began visiting regularly. Our schedules were not very compatible so I was able to visit Carlos and Elsa only once, but the visit let me discover how infatuated Carlos had become with Hawaii and the spiritual qualities of the Hawaiians and Kauai in particular. Now there was a whole new aspect to Carlos's artwork and he and I began planning a solo exhibition at the Contemporary Museum.

Unfortunately by this time Carlos had contracted AIDS and his health was failing. In 1989 we were finally able to mount *Carlos Almaraz: Recent Monotypes & Serigraphs*, exhibiting his new pastels and paintings reflecting his Hawaii inspiration. Tragically, the very day the exhibition opened to the public, Carlos passed away. His passing affects me still.

MONROE PRICE

Price was a professor at the UCLA School of Law and the founder of Los Angeles Lawyers for the Arts. He was involved in the negotiations between Los Four and the Los Angeles County Museum of Art during the mounting of the group's exhibition in 1974.

Carlos was deeply and properly concerned about how the idea of Chicano art (and more particularly the art of Los Four) entered into the Los Angeles consciousness, and ultimately, of course, to the world beyond L.A. He recognized the historic possibilities of art moving from the perilously vernacular to the precincts of the sacred, the sacred here being the privileged halls of the mainstream museum. He knew what some might consider little decisions would make a substantial difference in terms of the signals sent out to viewers, the various communities of interest, and patrons.

LACMA opened a stunning exhibition in February of 1974, complete with Gilbert Luján's dazzling *Lowrider's Regime*, a fabulously decorated automobile that the museum had previously considered dropping from the show. LACMA recognized, maybe not sufficiently, that this was an important moment for it as an institution and for Los Angeles as a vigorously diverse creative home. Los Four was fantastically proud of their distinctive contribution—as artists bringing visibility and institutional sanction to what was emerging. Carlos was proud of the accomplishments of Los Four, but he was conscious of the protean contributions of artist groups who were first narrowly branded, but became global figures of magnitude. He could see Los Four as an important vehicle, one that could open up imaginations and multiply creativity, not necessarily stay with a brand that could cramp it.

The tension between "Charles" vs. "Carlos" was a shorthand for the complexities of Almaraz's identity, style, and iconography. These complexities would be present in the discussions within Los Four, in the discussions between Los Four and LACMA and be further present during his wonderfully productive but tragically short life.

PATRICK ELA

Ela is a former museum director, public art consultant, and appraiser of fine art accredited by the American Society of Appraisers. He discusses the 1981 *Murals of Aztlán* exhibition.

In 1981, Frank Romero had an idea for a reverse exhibition where the opening would be at the end and the content would be created during the run. Edith Wyle and I were co-directors of the Craft and Folk Art Museum (CAFAM) at the time and approved Frank's proposal for the *Murals of Aztlán* immediately.

Oversized canvases were stretched over CAFAM's walls, and Carlos, the East Los Streetscapers (David Rivas Botello,

Wayne Alaniz Healy, and George Yepes) Judithe Hernández, Willie Herrón, Gronk, Frank Romero, and John Valadez all started painting. Veteran filmmaker Jim Tartan created a film also named *Murals of Aztlán* and chronicled the whole wonderful performance.

Carlos's mural was called *Sunset on the Fig* (1981). The ironic title referred to his image of the Hotel Figueroa in downtown L.A. burning down late one summer afternoon. As with his car crashes and other existential works, there was tremendous beauty in the conflagration and chaos of the hotel's potential demise.

By this time it was late 1989, and Carlos has been admitted to the hospital in Sherman Oaks. I made several visits to his studio and watched as he and Elsa painted side-by-side. I even saw her take a paintbrush and finish something that was on his canvas while he stood back to examine what she was doing.

After Carlos left us in December of 1989, Elsa finished the piece in what turned out to be one of the hottest summers in L.A. history. Consumed by heat, paint fumes, and sleepless nights and in mourning for her beloved husband, Elsa did it! She finished what the two of them had started side-by-side in their tiny studio.

JOAN AGAJANIAN QUINN

Quinn, a journalist and arts advocate, was the longest sitting member appointed to the California Arts Council (1981–97). Quinn recounts her role in the CAC's commission of Carlos Almaraz and Elsa Flores Almaraz's mural, *California Dreamscape*, for the lobby of the Ronald Reagan State Building in downtown Los Angeles.

Due to my love for public art, I was brought on—along with the state architect and a political appointee—to form the CAC team that would select the art for the building in 1987. We went through the usual procedure of advertising and judging the art to be chosen. We decided on a few artists: Billy Al Bengston, Gwynn Murrill, and the team of Carlos Almaraz and Elsa Flores.

After seeing the prospective work of each artist, we made studio visits as a team and watched the works progress. Carlos and Elsa presented a plan for a very long, lyrical mural with swaying buildings, helicopters, and gusts of wind blown by angels. A jury of builders and politicians who happened to see it immediately squelched the mural. The powers that be asserted their concern that it looked like an earthquake was rocking the city. Needless to say, that was the end of that painting; however, with our selection team's assistance and because the artists were listening to directions, the couple submitted alternative maquettes. We decided on the right one and their groundwork started. Elsa and Carlos were ready to go.

JEFFREY VALLANCE

Vallance is an artist and writer who met Almaraz in the early 1980s; the two discovered that they shared an interest in Polynesian art, among other topics. This is excerpted from an interview with Marielos Kluck.

I remember the one [thing] that he would say: he wants to be known as an *artist*, just plain artist, he doesn't want there to be prefix in front of his name. He doesn't want to be an "L.A. artist" or a "California artist" or a "Chicano artist," he just wants to be an artist. I think that kind of sums up how he thought of himself and his work. He was looking [for] a broader audience and didn't really want to be labeled. He was branching out into other myths, like Hawaiian—he was really into that. He was looking at world cultures. Not just L.A. and not just Chicano. He was interested in all kinds of myths.

MARK GUERRERO

Guerrero is a singer, songwriter, recording artist, and Chicano music historian who, like his brother Dan Guerrero, knew Almaraz since childhood. He recollects his motivation to write "The Ballad of Carlos Almaraz."

When I was three years old, my older brother Dan took me by the hand as we walked up McDonnell Avenue in East Los Angeles to meet Carlos and his younger brother Ricky. The Almaraz

family lived a block up the street from our family home. Carlos was my brother's best friend and Ricky, who was my age, became mine. I remember clearly to this day the four of us standing around a fig tree in their front yard. Because Carlos was eight years my senior, a huge age difference between children, we developed our own friendship when I became an adult and my brother had moved to New York.

I have many treasured memories of Carlos. In 1968, when I was eighteen years old, I went to New York to visit my brother. While I was there, I visited Carlos in SoHo. I was still living at home in the suburbia of Monterey Park, California. In contrast, Carlos was living in a big loft surrounded by his paintings in a very hip artists' colony. I remember him playing the Beatles' "I Am the Walrus" at an extremely high volume at three a.m. with his windows wide open. Since he was in SoHo, no one complained. It blew my young mind that someone could live with such freedom.

A few years later, in 1972, Carlos invited my band to play at a small art gallery in East L.A. for the opening of an exhibition of his work. He didn't have money to pay us, but since he was a friend whose work we supported, we came to play anyway. After our performance, he gave each of us one of his watercolor pieces. I still have mine—an image of a dog sitting by a magician's table at night with a crescent moon above.

In 1992, after Carlos's passing, my father Lalo and I were invited to write songs about Carlos for a memorial tribute event at LACMA. I wrote a heartfelt song called "The Ballad of Carlos Almaraz" and was honored to sing it at the event. To me Carlos Almaraz is unparalleled in Chicano art because of the originality, quality, quantity, and diversity of his work. He was a great artist, a great friend, and I miss him. However, with special people you get to know during your lifetime, some become a part of you. Carlos is still with me.

"THE BALLAD OF CARLOS ALMARAZ"

Sunset over Echo Park, L.A.'s winding down
A candy apple red horizon glowing on the town
An artist with a canvas a palette and a brush
Captured its magnificence and gave it all to us

Let us remember a friend forever
A brother *además*
Propose a toast and raise a glass
To Carlos Almaraz

Two mad dogs battle for a bone, an image of burning greed
Crashing cars on boulevards, the futility of speed
Pouring out his heart and soul in colors true and bold
Imagination brought to life forever to behold

Let us remember a friend forever
A brother *además*
For all of that I tip my hat
To Carlos Almaraz

He worked with gangs in East L.A.
With Cesar Chavez too
A man who cared, a man who shared
His vision with me and you

He cut sugarcane in Cuba, he always was a dreamer
Walked on the Great Wall of China, sailed to Europe
on a steamer
Forever chasing windmills, searching for the way
He found his final resting place by the shores of Hanalei

Let us remember a friend forever
A brother *además*
Thanks for all of it, we won't forget you
Carlos Almaraz

Checklist of the Exhibition

NOTE: Object information is as provided by lenders. Almaraz generally titled his works in English, with some provided here in Spanish (with English) by preference of the lenders. For dimensions, height precedes width. Checklist is final as of March 2017.

Big Bang, 1971
Ink and watercolor on paper
15 × 20 in. (38.1 × 50.8 cm)
Elsa Flores Almaraz
p. 65 bottom

The Conjurors' Power of Suggestion, 1972
Acrylic on canvas
72 ⅛ × 54 in. (183.2 × 137.2 cm)
Crocker Art Museum Purchase, with funds from the Maude T. Pook Acquisition Fund
p. 83

Frenzied Fantasies, 1972
Ink and watercolor on paper
15 × 20 in. (38.1 × 50.8 cm)
Elsa Flores Almaraz
p. 64

The Muffing Mask, 1972
Ink on paper
15 × 20 in. (38.1 × 50.8 cm)
Elsa Flores Almaraz
p. 65 top

Siesta, 1972
Ink and watercolor on paper
15 × 20 in. (38.1 × 50.8 cm)
Elsa Flores Almaraz
p. 62

La Llorona de los Siglos (The Weeping Woman), 1973
Acrylic on canvas
72 ⅛ × 53 ¾ in. (183.2 × 136.5 cm)
Gary and Anne Borman Family
p. 87

Shoot Out, 1978
Acrylic on canvas
15 × 24 in. (38.1 × 61 cm)
The Buck Collection through the University of California, Irvine
p. 48

Glendale Boulevard, 1979
Pastel on paper
19 × 25 in. (48.3 × 63.5 cm)
Collection of Leslie and Ron Ostrin
p. 33

Tomorrow, 1979
Oil on canvas
18 × 20 in. (45.7 × 50.8 cm)
Durón Family Collection
p. 32

Abajo del agua (Under the Water), 1980
Pastel on paper
19 ½ × 25 ⅛ in. (49.5 × 63.8 cm)
Carol Goldstein and Bernard Nadel
p. 68

Hollywood Saga, 1980
Acrylic on canvas
15 × 24 in. (38.1 × 61 cm)
Maya Almaraz
p. 86

The Red Chair, 1980
Oil on paper
22 × 30 in. (55.9 × 76.2 cm)
Dr. Eugene Rogolsky, promised gift to the USC Fisher Museum of Art
p. 54

Uno caballo y una vaca (A Horse and a Cow), 1980
Pastel on paper
19 ½ × 25 ½ in. (49.5 × 64.8 cm)
Beth and Jim Preminger
Not illustrated

Domestic Icons, 1981
Oil on canvas
15 × 18 ¾ in. (38.1 × 47.6 cm)
Elsa Flores Almaraz
p. 53

Echo Park Lake no. 1, 1982
Oil on canvas
72 × 72 in. (182.9 × 182.9 cm)
Margery and Maurice Katz
p. 27

Echo Park Lake no. 2, 1982
Oil on canvas
72 × 72 in. (182.9 × 182.9 cm)
Paul Hastings LLP
p. 27

Echo Park Lake no. 3, 1982
Oil on canvas
72 × 72 in. (182.9 × 182.9 cm)
Paul Hastings LLP
p. 27

Echo Park Lake no. 4, 1982
Oil on canvas
72 × 72 in. (182.9 × 182.9 cm)
Collection of Leslie and Ron Ostrin
p. 27

Europe and the Jaguar, 1982
Oil on canvas
72 × 72 in. (182.9 × 182.9 cm)
Corcoran Collection, gift of the Friends of the Corcoran, CGA.1988.6.1
p. 69

Greed, 1982
Oil on canvas
35 ½ × 43 in. (90.2 × 109.2 cm)
Collection of Lynn and John Pleshette
p. 47

Longo Crash, 1982
Acrylic on canvas
18 × 54 in. (45.7 × 137.2 cm)
Collection of Patty and Michael Gold
p. 44

Magic Green Stage, 1982
Oil on canvas
70 × 70 in. (177.8 × 177.8 cm)
The Buck Collection through
the University of California, Irvine
p. 85

Mr. and Mrs. Rabbit Go to Town, 1982
Pastel on paper
29 × 44 in. (73.7 × 111.7 cm)
Collection of Robert M. DeLapp
p. 78

Sunset Crash, 1982
Oil on canvas
35 × 43 in. (88.9 × 109.2 cm)
Courtesy of the Cheech Marin Collection
p. 41

West Coast Crash, 1982
Oil on canvas
18 × 54 in. (45.7 × 137.2 cm)
Elsa Flores Almaraz
p. 43

Early Hawaiians, 1983
Oil on canvas
72 × 163 in. (182.9 × 414 cm)
Los Angeles County Museum of Art,
gift of William H. Bigelow, III, M.91.288a c
pp. 34–35

Hawaiian Nocturne, 1983
Pastel on paper
18 ¾ × 24 ½ in. (47.6 × 62.2 cm)
Collection of Sergio and Juana Muñoz,
Redondo Beach
p. 37

Kauai Nocturne, 1983
Pastel on paper
19 ⅜ × 25 ⅛ in. (49.2 × 63.8 cm)
The Bank of America Collection
p. 36

Love Makes the City Crumble, 1983
Oil on canvas
66 × 66 in. (167.6 × 167.6 cm)
Kelvin Davis
p. 29

Rocking the Baby, 1983
Oil on canvas
52 × 74 in. (132.1 × 188 cm)
Collection of Glaser Weil LLP
p. 55

Suburban Nightmare, 1983
Oil on canvas
37 × 45 in. (94 × 114.3 cm)
The Buck Collection through
the University of California, Irvine
p. 4

That Guy, 1983
Oil on canvas
24 × 20 in. (61 × 50.8 cm)
The Robert E. Holmes Collection
p. 63

Bridge in Deep Magenta, 1984
Oil on canvas
60 × 50 in. (152.4 × 127 cm)
The AltaMed Art Collection, courtesy of
Cástulo de la Rocha and Zoila D. Escobar
p. 31

Crash in Phthalo Green, 1984
Oil on canvas
42 × 72 in. (106.7 × 182.9 cm)
Los Angeles County Museum of Art,
gift of the 1992 Collectors Committee,
AC1992.136.1
p. 6

Creatures of the Earth, 1984
Oil on canvas
43 × 35 in. (109.2 × 88.9 cm)
Courtesy of the Cheech Marin Collection
p. 76

*The Gods Who Found Water
(Los Dioses que encontraran agua)*, 1984
Oil on canvas
32 ¼ × 72 ¼ in. (81.9 × 183.5 cm)
The Bank of America Collection
p. 77

Night Theater, 1984
Pastel on paper
35 ½ × 49 ½ in. (90.1 × 125.7 cm)
Collection of Alfred Fraijo Jr. and Arturo
Becerra, courtesy of the Carlos Almaraz
Estate Collection
p. 70

Over the Edge, 1984
Oil on canvas
32 × 54 in. (81.3 × 137.2 cm)
J. Nicholson
p. 42

Starry Night, Echo Park, 1984
Oil on canvas
36 × 46 in. (91.4 × 116.8 cm)
Ackerman Family Collection
p. 30

The Struggle of Mankind, 1984
Pastel on paper
19 ½ × 25 ½ in. (49.5 × 64.8 cm)
Collection of Caroline Croskery
and Thomas Pyle
p. 61

Cat Man's Wedding, 1985
Oil on canvas
46 × 36 in. (116.8 × 91.4 cm)
Collection of Nannette Nesbitt, New York City
p. 90

Mito de luz de luna (Moonlight Myth), 1985
Oil on canvas
66 × 156 in. (167.6 × 396.2 cm)
The Bank of America Collection
pp. 74–75

Perpendicular Crash, 1985
Oil on canvas
18 × 54 in. (45.7 × 137.2 cm)
Lichter Marck Family Trust
p. 40

The Crossing, 1986
Oil on canvas
24 × 24 in. (61 × 61 cm)
The Buck Collection through
the University of California, Irvine
p. 72

The Eternal City, 1986
Oil on canvas
58 × 54 in. (147.3 × 137.2 cm)
Duker Collection, Pasadena
p. 79

The Two Chairs, 1986
Oil on canvas
79 ½ × 66 in. (201.9 × 167.6 cm)
Courtesy of the Cheech Marin Collection
p. 52

Two of a Kind, 1986
Oil on canvas
83 ½ × 69 ½ in. (212.1 × 176.5 cm)
Los Angeles County Museum of Art, gift of
Charles Anthony Seiniger, AC1999.134.1
p. 91

Yellow Morning, 1986
Oil on canvas
72 × 108 in. (182.9 × 274.3 cm)
The AltaMed Art Collection, courtesy of
Cástulo de la Rocha and Zoila D. Escobar
pp. 88–89

Buffo's Lament, 1987
Oil on canvas
66 × 66 in. (167.6 × 167.6 cm)
Deloitte
p. 82

Looking at the Future, 1987
Pastel on paper
53 × 39 in. (134.6 × 99.1 cm)
Collection of Glaser Weil LLP
Not illustrated

The Magician, 1987
Oil on canvas
48 × 39 ¾ in. (121.9 × 101 cm)
Deloitte
p. 81

The Magician, 1987
Oil on canvas
8 ½ × 6 ½ in. (21.6 × 16.5 cm)
Durón Family Collection
p. 80

Murder, 1987
Oil on canvas
48 × 36 in. (121.9 × 91.4 cm)
Collection of Patty and Michael Gold
p. 49

Tree of Life, 1987
Oil on canvas
84 ⅛ × 66 in. (213.7 × 167.6 cm)
The Buck Collection through
the University of California, Irvine
p. 73

California Natives, 1988
Oil on canvas
60 × 84 in. (152.4 × 213.4 cm)
Courtesy of the Cheech Marin Collection
pp. 22–23

City Jaguar, 1988
Oil on canvas
60 × 50 in. (152.4 × 127 cm)
Ed and Sandy Martin
p. 71

Growing City, 1988
Pastel on paper
35 ½ × 49 ½ in. (90.2 × 125.7 cm)
Elsa and Maya Almaraz
p. 24

House Motif, 1988
Oil on canvas
48 × 54 (121.9 × 137.2 cm)
Van Fletcher and Skip Paul
p. 56

Naked Jester, 1988
Oil on canvas
48 × 42 in. (121.9 × 106.7 cm)
Collection of the USC Fisher Museum of Art,
Los Angeles, gift of Dr. Eugene Rogolsky
p. 60

School Days, 1988
Oil on canvas
60 × 80 in. (152.4 × 203.2 cm)
Los Angeles County Museum of Art,
promised gift of Gloria and Newton D. Werner
p. 57

Chatita Kitty, 1989
Oil on canvas
20 × 30 in. (50.8 × 76.2 cm)
Collection of Patty and Michael Gold
p. 46

Deer Dancer, 1989
Oil on canvas
48 × 36 in. (121.9 × 91.4 cm)
Elsa and Maya Almaraz
p. 84

Echo Park Bridge at Night, 1989
Oil on canvas
60 × 72 in. (152.4 × 182.9 cm)
The Buck Collection through
the University of California, Irvine
p. 2

Return of the King, 1989
Oil on canvas
42 ⅜ × 32 ⅜ in. (107.6 × 82.2 cm)
Elsa and Maya Almaraz
p. 92

Lenders to the Exhibition

Ackerman Family Collection

Elsa Flores Almaraz

Maya Almaraz

The AltaMed Art Collection,
courtesy of Cástulo de la Rocha
and Zoila D. Escobar

The Bank of America Collection

Gary and Anne Borman Family

The Buck Collection through
the University of California, Irvine

Corcoran Collection

Crocker Art Museum

Caroline Croskery and Thomas Pyle

Kelvin Davis

Robert M. DeLapp

Deloitte

Duker Collection

Durón Family Collection

Van Fletcher and Skip Paul

Alfred Fraijo Jr. and Arturo Becerra

Glaser Weil LLP Collection

Patty and Michael Gold

Carol Goldstein and Bernard Nadel

The Robert E. Holmes Collection

Margery and Maurice Katz

Lichter Marck Family Trust

The Cheech Marin Collection

Ed and Sandy Martin

Sergio and Juana Muñoz

Nannette Nesbitt

J. Nicholson

Leslie and Ron Ostrin

Paul Hastings LLP

Lynn and John Pleshette

Beth and Jim Preminger

Dr. Eugene Rogolsky

USC Fisher Museum of Art

Gloria and Newton D. Werner

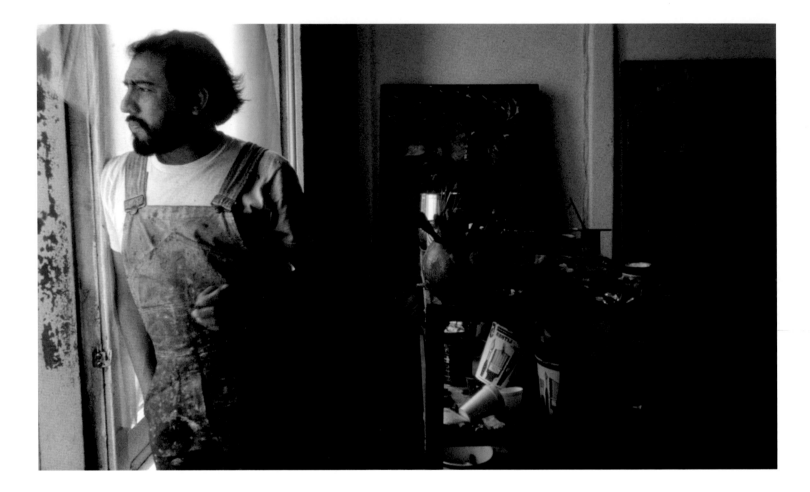

At the Spring Street studio, 1986

Acknowledgments

Anticipating the public presentation of an exhibition of an immensely talented artist as an inclusive survey in a major museum nearly three decades after his death, is, for me as curator, both thrilling and humbling—thrilling because it is a well-deserved honor for the artist, and humbling because so many individuals working across a spectrum of disciplines are involved in achieving the project's full potential. This presentation has involved the goodwill and earnest efforts of family, friends, and colleagues of Carlos Almaraz as well as the hard work of numerous museum professionals and the generosity of our sponsors and lenders. I express my enormous gratitude to all who have contributed to the realization of *Playing with Fire: Paintings by Carlos Almaraz.*

I am indeed grateful to have been invited by LACMA's CEO and Wallis Annenberg Director Michael Govan to organize this show as guest curator. Collector and entertainer Cheech Marin was a longtime advocate for this exhibition, and it was he who proposed my participation to Michael; I heartily thank both of them for the opportunity to bring Almaraz's accomplishments to LACMA's vast audience.

The Getty Foundation, through the launch of Pacific Standard Time: LA/LA—a region-wide, multi-institutional exhibition initiative exploring the cross-pollination of art and ideas between Los Angeles and Latin America—was an early supporter of research and planning for this project, and I join LACMA in saluting their institutional, financial, and collegial support. Likewise, I share my personal gratitude for the generous underwriting of LACMA's corporate sponsor, Bank of America.

I served as curator of contemporary art at LACMA from 1985 through 2008, and in accepting Michael Govan's invitation to organize this show, I was pleased for the opportunity to work with LACMA colleagues old and new. It is with great appreciation and personal warmth that I acknowledge the elemental contributions of some of them here.

I especially recognize the dream team of Zoe Kahr, deputy director for exhibitions and planning; Sabrina Lovett, senior exhibition coordinator; and Iris Jang, exhibition programs administrator. Consummate professionals, they attended to all the organizational aspects of this project, from shepherding the first draft of the exhibition proposal through its institutional paces, to overseeing the physical production of the show. Franklin Sirmans, former Terri and Michael Smooke Curator and department head of contemporary art at LACMA, and Rita Gonzalez, curator and acting department head of contemporary art, lent their enthusiastic support to this presentation from start to finish, and I appreciate both their collegiality and their friendship. Curatorial assistant Meghan Doherty, also of the contemporary art department, was my constant and ever-reliable partner in realizing this exhibition and working with lenders. Research assistant David de Rozas provided nimble intelligence in selecting and displaying the ephemera—including Almaraz's personal notebooks, sketches, and photos—included in the exhibition.

My deepest respect and appreciation go to the museum's development department, especially Katie Kennedy, Sophia Kritselis, Kris Lewis, Jennifer Snow, Celia Yang, and former staff member Kate Virdone. They worked tirelessly with our donors and sponsors, in particular with Allen Blevins and Garrett Gin of Bank of America in underwriting this show. In Marketing and Communications, John Rice smartly conceived the advertising strategy for this presentation and worked to establish its institutional identity; the ever-resourceful, ever-astute Miranda Carroll brought this show to the attention of LACMA's popular and critical audiences.

Creating exhibition catalogues has always been, for me, the most challenging and fulfilling aspect of curatorial responsibilities. Indeed, writing this catalogue has allowed me to explore and express my most intimate engagement with the art and life of Carlos Almaraz. But I could not have done it without the invaluable expertise and editorial partnering with the museum's publisher, Lisa Mark, whose vision of integrating both print and digital media—an extended version of the "Other Voices" chapter appears at lacma.org—has propelled LACMA to the forefront of museum publishing in the twenty-first century. Senior editor Sara Cody is gifted in her talent and insightfulness, and she's a good friend, too; any author would be more than fortunate to have her as an editor and collaborator. Piper Severance efficiently secured all the necessary clearances and permissions for this copiously illustrated publication. Maja Blazejewska, under the art direction of David Karwan, conceived and executed the handsome design of this book. We applaud their collective creative skills.

Special acknowledgment is in order for my fellow contributors to this catalogue. Elsa Flores Almaraz, Carlos's wife and documentarian, and an artist in her own right, chose the illuminating passages from Carlos's personal journals, published here for the first time, as well as contributed a moving excerpt of a longer biographical text written with Jeffrey J. Rangel. Chicago-based independent curator Marielos Kluck solicited, edited, and arranged the numerous reminiscences from artists, collectors, critics, and other art professionals who knew Almaraz. My thanks to her, and to everyone who contributed, for so enriching this publication.

Elsa and her daughter, Maya Almaraz, were joint donors of a comprehensive gift to LACMA featuring some seventy fine examples of Carlos's works on paper, many of them shown at LACMA in a tribute exhibition to him in 1992, and they have continued their support of both Carlos and the museum throughout the production of this survey of his paintings. I share with them my deepest personal thanks.

I am especially grateful for an article published in the *Los Angeles Times* by Reed Johnson on March 8, 2014, which solicited information from individual collectors of Almaraz's artworks in an effort to discover the whereabouts of many works. Hundreds responded to LACMA's Almaraz research hotline, and many of the lenders to this exhibition were among them. LACMA joins me in thanking all those respondents; their correspondence has contributed to our collective awareness of Almaraz's accomplishment and is archived in the museum's digital research files, to be available to future researchers. Thanks as well to Craig Krull Gallery, Santa Monica, for its unflagging assistance in locating collectors and current owners of Almaraz's paintings and pastels. Along with the Almaraz Estate, the Buck Collection—the private collection of California art amassed by the late Gerald E. Buck—is the most represented lender in the show, with six masterworks by Almaraz; I am extremely grateful to Thor Hougan, friend of the Buck Estate, and collection manager Isabella McGrath, for enabling the loan of these works through the Collection's beneficiary, the University of California, Irvine.

It goes without saying that this exhibition would not occur without the achievement of Carlos Almaraz. Just as significant in the realization of this show is the willingness of its many lenders to share their works publically with LACMA's wide audience. Their participation attests to the passion, deep respect, and enthusiasm that Almaraz inspired during his lifetime—and continues to inspire among his ardent collectors and those viewers already familiar with his art, as well as, I trust, those encountering it for the first time.

Howard N. Fox
Curator Emeritus, Contemporary Art
Los Angeles County Museum of Art

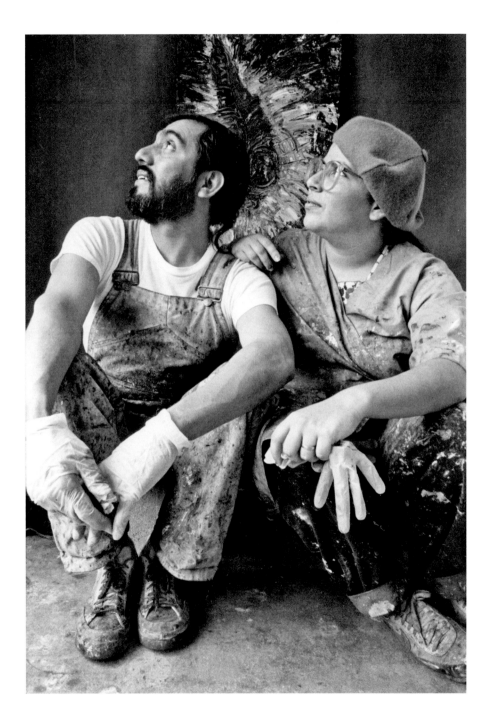

Carlos and Elsa Almaraz, Spring Street studio, 1980s

Photo credits

Published in conjunction with the exhibition
Playing with Fire: Paintings by Carlos Almaraz
at the Los Angeles County Museum of Art,
August 6–December 3, 2017.

This exhibition was organized by the Los Angeles County Museum of Art.

Presenting Sponsors

The Getty

Bank of America

Bank of America is the presenting sponsor of *Playing with Fire: Paintings by Carlos Almaraz.*

Bank of America

Support is provided by the Getty Foundation as part of Pacific Standard Time: LA/LA.

 The Getty Foundation

Additional funding provided by Ann Murdy.

Los Angeles County Museum of Art
5905 Wilshire Boulevard
Los Angeles, California 90036
www.lacma.org

Copyright © 2017 Museum Associates/Los Angeles
County Museum of Art and Prestel Verlag, Munich,
London, New York

Playing with Fire:
Paintings by Carlos Almaraz
PUBLISHER: Lisa Gabrielle Mark
SENIOR EDITOR: Sara Cody
DESIGNERS: David Karwan & Maja Blazejewska
PHOTO EDITOR: Piper Severance
PRODUCTION DIRECTOR: Karen Farquhar
for DelMonico Books • Prestel

FRONT COVER: *Suburban Nightmare* (detail), 1983
BACK COVER: *That Guy* (detail), 1983
PAGE 1: *City Jaguar* (detail), 1988

Printed and bound in China

Copublished by Los Angeles County Museum
of Art and DelMonico Books, an imprint of
Prestel Publishing, a member of Verlagsgruppe
Random House GmbH
Prestel Verlag
Neumarkter Strasse 28
81673 Munich

Prestel Publishing Ltd.
14–17 Wells Street
London W1T 3PD

Prestel Publishing
900 Broadway, Suite 603
New York, NY 10003
www.prestel.com

ISBN 978-3-7913-5685-3

Library of Congress Cataloging-in-Publication Data

Names: Fox, Howard N. Playing with fire. | Container
of work: Almaraz, Carlos. Paintings. Selections. |
Los Angeles County Museum of Art, organizer, host
institution.
Title: Playing with fire : paintings by Carlos Almaraz /
Howard N. Fox ; with an essay by Elsa Flores Almaraz,
with Jeffrey J. Rangel ; contributions by Maya Almaraz,
Barbara Carrasco, Patrick Ela, Fritz A. Frauchiger,
Marielos Gluck, Dan Guerrero, Mark Guerrero, Judithe
Hernández, Wayne Alaniz Healy, Craig Krull, Gina
Lobaco, Cheech Marin, Suzanne Muchnic, Louie F.
Pérez, Aimée Brown Price, Monroe Price, Joan
Agajanian Quinn, John Valadez, and Jeffrey Vallance ;
featuring excerpts from the journals of Carlos Almaraz.
Other titles: Playing with fire (Los Angeles County
Museum of Art)
Description: Los Angeles : Los Angeles County Museum
of Art ; Munich ; New York : DelMonico Books/Prestel,
2017. | "Published with the assistance of the Getty
Foundation." | "Published in conjunction with the
exhibition Playing with Fire: Paintings by Carlos Almaraz
at the Los Angeles County Museum of Art, August 6–
December 3, 2017." | Includes bibliographical references.
Identifiers: LCCN 2017010373 | ISBN 9783791356853
(978-3-7913-5685-3)
Subjects: LCSH: Almaraz, Carlos—Exhibitions.
Classification: LCC ND237.A415 A4 2017 | DDC
759.13—dc23
LC record available at https://lccn.loc.gov/2017010373

A CIP catalogue record is available from the British Library